IMAGES
of Rail

RAILS AROUND
FORT WORTH

On the Cover: Fort Worth & Denver City employees stand on a steam engine in Childress County. As times changed, both men and women had a role in the operations of the railroads. The offices became integral parts of the communities where previously unconnected people came together and celebrated their roles, as in this posed photograph for the railroad. Clearly, being a part of the railroad meant being part of the larger American narrative in settling the frontier. (Courtesy of Childress County Heritage Museum.)

IMAGES
of Rail

Rails Around Fort Worth

Ian Taylor

Copyright © 2014 by Ian Taylor
ISBN 978-1-4671-3168-1

Published by Arcadia Publishing
Charleston, South Carolina

Printed in the United States of America

Library of Congress Control Number: 2013953175

For all general information, please contact Arcadia Publishing:
Telephone 843-853-2070
Fax 843-853-0044
E-mail sales@arcadiapublishing.com
For customer service and orders:
Toll-Free 1-888-313-2665

Visit us on the Internet at www.arcadiapublishing.com

*To my wife, Lauren, who has the patience of
a saint and a heart the size of Texas*

Contents

Acknowledgments		6
Introduction		7
1.	The Arrival of the Railroad	9
2.	Becoming a City	33
3.	Prairie to Powerhouse	61
4.	Beyond Cattle	83
5.	Merging into the "Metroplex"	103

Acknowledgments

To begin with, as with many authors, I have to thank my wife, Lauren, for all of her support throughout this entire process. She provided encouragement whenever it was needed and was more patient than I could have hoped. Secondly, I would like to thank my family, and in particular my recently deceased grandmother, who fostered an interest in history in me at an early age and let me thumb through all her local histories in her library. My editor, Laura Bruns, had an enormous amount of patience and prodded me whenever I needed it.

However, the real thanks that I and the entire community should give is to the tireless archivists, librarians, and local historians who enthusiastically field questions and give us the gift of history at our fingerprints at little or no cost. In particular, I would like to thank Thomas Kellam of Tarrant County Community College, who met and discussed the project with me in its early stages. Thanks are also owed to Suzanne Fritz of the Fort Worth Public Library, who showed me the rich archival materials in the library's possession. Thanks also to Cathy Spitzenberger of the University of Texas at Arlington; I am very grateful for all her help with historic images from around the Fort Worth area.

Additionally, I would like to thank the Museum of the American Railroad in Frisco, Texas. This museum is a true hallmark to an important chapter in Texan history. I would like to thank the museum for providing a rich history of the railroads in both Texan and American history and wish it luck in its new location.

The Portal to Texas History should be recognized for the wonderful gateway that it is for young researchers such as me. Thanks go to all who have contributed to this gateway and to all the librarians at the University of North Texas who maintain it.

INTRODUCTION

Americans have long had an interest in the railroad and the role it played in the story of the Old West. From the moment the first transpacific line was complete to now, locomotives have traveled across the immense plains of the American West, bringing people and freight across the landscape. Each city sought and jockeyed for railroad connections, and the city of Fort Worth fought hard for the Texas & Pacific to come to town.

Few places in America could have gathered a coalition of city leaders, workers, and politicians to come out to ensure the laying of a track to connect the small town. When the Texas & Pacific Railroad connected to Fort Worth in 1876, little of what was to come to the city could have been envisioned. Just as in other frontier towns, the railroad was like a river coming to quench the thirst of townspeople wanting a taste of the markets and goods that traveled across the tracks.

The city of Fort Worth has always taken great pride in being known as the "Gateway to the West," and the railroads made that possible. Rail lines coming from the East connected in Fort Worth before moving across the wide plains of Texas and on to California. Some of the most famous railroads in history ran through the city and carried what was probably the most coveted good that the city had to offer, livestock. From the famous Fort Worth Stockyards came cattle that were shuttled northward to Kansas City and Chicago. Later, when oil was discovered, Fort Worth became a transit point for oil found in West Texas and carried to energy-hungry markets across the country.

Just as Fort Worth contributed to the growing appetites of the young American nation, so it also reaped the rewards that the railroad brought. The Texas & Pacific Railroad established its headquarters in the city and constructed a station that the city counted as one of its finest landmarks. The city needed all the clothes, goods, food, and amenities that the trains hauled into Fort Worth and filled the stocks and shelves of drugstores, hardware stores, and department stores.

Yet there are also plenty of other dimensions to the story of the railroad in Fort Worth. The interurban railroad connected Fort Worth with its rival, Dallas, in the east. It allowed the people of Fort Worth to travel across town and visit the parks and recreational areas. The story of the interurban is the city's first form of public transportation as it changed from a mule-driven cart to electrification in the first decades of the 20th century. This early precursor to the modern local passenger train was a custom sight in the city in its early years.

The railroads connected Fort Worth to the rest of the nation in prestigious ways as well. Cowboy celebrities and gunslingers came to the town that established itself as a landmark in the Old West. Both Presidents Theodore and Franklin Roosevelt made visits to the city along the railroad more than once during their administrations. During World War I, Americans arrived on the trains to train at Camp Bowie to prepare for the battlefields of Europe.

Fort Worth citizens could observe all the striking models of locomotives that passed through town. The steam locomotives that chugged through town grew in size and accelerated to greater speeds. Gradually, they were replaced by the diesel locomotives that came around in the 1930s

and the postwar years. By the 1950s, the streamliner railroads shuttled passengers and freight with a slick, contemporary design across the wide expanses of the state.

In the decades following the end of World War I, alternative modes of transportation emerged that would eventually eclipse the railroad. Aviation came to Fort Worth with the building of Meacham Field, and automobiles gradually gained momentum as the streets that were once thronged with horse-driven carriages made way for cars and trucks. With the establishment of the bomber plant in World War II, the city became a vital manufacturing center for the Allied war effort.

Though the quantity of freight and passengers fell in the postwar years, the railroad was never forgotten in the role it played in developing the city. The Texas & Pacific station with its Art Deco design still stands over the Fort Worth downtown, and trains still pass through the city regularly. The railroad is as important to the city's success as livestock and played a more important role in building the city into the vibrant metropolis it is today than aviation has.

The American West has for long been dotted with cities that each have beginnings that trace back to the first railroads that came to small, beleaguered communities. Yet not many towns brought their railroads through sheer will and muscle like Fort Worth. The townspeople could not have known what a metropolis a modest-sized town could become, and though future technologies will change the city in yet more ways, it is possible to trace nearly everything it is today back to the railroad. Today, the locomotives chug through the town.

One
THE ARRIVAL OF THE RAILROAD

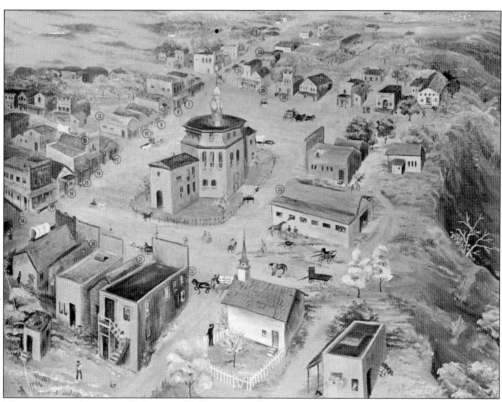

This painting by Miranda Leonard of Fort Worth in 1873 depicts a quaint little frontier town. Reflecting on Fort Worth in the early 1870s, the June 1, 1902, issue of the *Fort Worth Register* called the town "a dirty, dreary, cold, mean little place." However, by this time, the great appetites in Northern American markets for beef were drawing Texas cowherds north to Kansas. Fort Worth was a central stop on the McCoy-Chisholm Trail. In 1873, Fort Worth had one newspaper, three schools, two stone churches, a Masonic hall, a flour mill, a cotton gin, 30 businesses, three doctors, three lawyers, a tavern, and a courthouse. (Courtesy of Where the West Begins: Capturing Fort Worth's Historic Treasures, Special Collections, University of Texas at Arlington Library.)

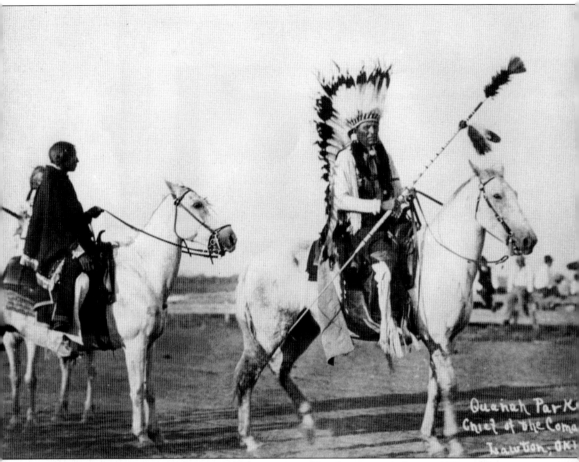

Much of the early frontier history of Texas saw conflict between settlers and Native Americans. However, by the early 1870s, Fort Worth was distant from those tensions. The famous Comanche chief Quanah Parker became an iconic figure who not only represented a vibrant and proud Indian tribe but also was symbolic of an era of frontier history that Texans were very aware of. The settling of this conflict opened up the possibilities for cattle drives and railroad construction that followed on its heels. (Courtesy of Tarrant County College District Archives.)

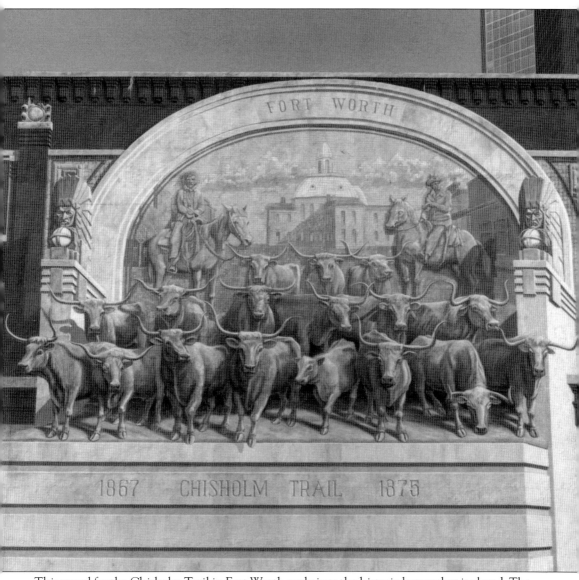

This mural for the Chisholm Trail in Fort Worth enshrines the historic legacy that it played. The trail was an arduous trek across largely unsettled territory and taxed the endurance of cowboys. The cowboys delivered record numbers of cattle and more than saturated the appetites of northern beef markets. Without the trail, it is doubtful that railroads would have found reason to connect in Fort Worth. (Courtesy of Cattle Raisers Museum.)

The cattle drives are really the key impetus for the arrival of the railroads. In 1870, an estimated 300,000 head of cattle were brought to Kansas along the Chisholm Trail. The following year, that number would double, flooding the market for beef cows that year. The Corn Belt cattle outmatched the muscular Texas longhorn that year, though this was only a setback, as the cattle drives continued. (Courtesy of George Ranch Historical Park.)

In 1870, Texas had an estimated 583 miles of railroad, much of which was constructed prior to the Civil War and centered around Houston and into Southeast Texas. The Houston & Texas Central was the only railroad to move inland from the coast. However, that year, Texas reentered the Union, which provided the state with control over its internal development. Within the next few years, railroad lines would be constructed throughout much of the eastern half of the state. (Courtesy of Palestine Public Library.)

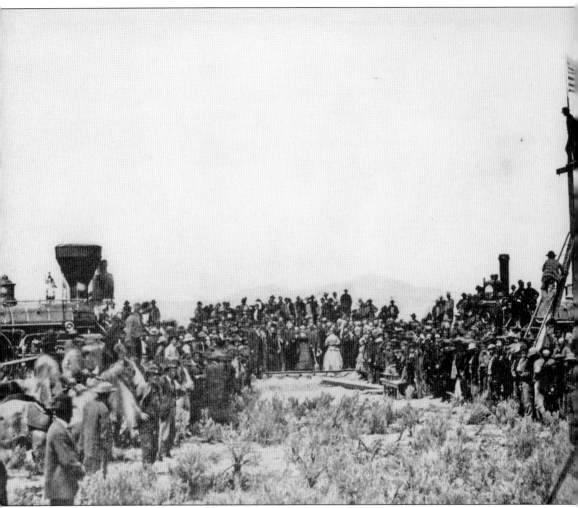

The dawn of the age of the transcontinental railroad achieved its first hallmark when the Golden Spike was struck in Promontory, Utah, on May 10, 1869. This first transcontinental between the Union Pacific and Central Pacific Railroads ran a line between Council Bluffs, Iowa, and San Francisco, California. Congress had authorized the two railroads to begin construction in the summer of 1864. This would mark a new chapter in the railroad's and the American West's history, as American settlement would spread across the interior over the coming decades. Aided by a transportation network capable of shuttling goods, equipment, and passengers over long distances in a short time, previously small settlements like Fort Worth would become cities in the span of a few decades. (Courtesy of University of Texas at Arlington Library.)

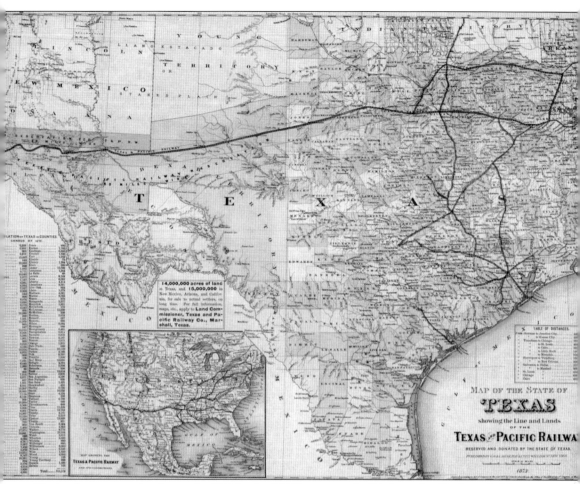

Having been granted a charter in 1871 by the US Congress to build along the 32nd parallel from Marshall, Texas, to San Diego, California, the Texas & Pacific Railroad began to plan a route connecting the Texas coast and the Pacific Ocean. The Texas & Pacific would fulfill a need for a transcontinental that was not snowbound for part of the year and was much shorter than its northern counterparts. The following year, Col. Thomas Scott, a mine owner, railroad baron, and former assistant secretary of war, was elected as the leader of the enterprise. He bought and merged several railways and plotted throughout the summer and winter of 1871 where to lay the lines and tracks across the country to the coast. (Courtesy of University of North Texas Libraries.)

In June 1872, Scott and a small party that included former Texas governor James Throckmorton (above); John Forney, the editor of the *Philadelphia Chronicle*, and D.W. Washburn, an engineer, arrived in Fort Worth to consider the path through the small town. Colonel Scott wanted 320 acres south of Fort Worth and negotiated with several local landowners for the land rights. Throckmorton was appointed as a director of the railroad and was a particularly astute political choice for handling the most critical portions of the project in Texas. (Courtesy of Tarrant County College District Archives.)

This is a sketch of Ephraim M. Daggett, who played a critical role, along with Col. Thomas Jennings, Judge H.G. Hendricks, and Maj. K.M. Van Zandt, in granting the necessary land to bring the railroad to Fort Worth. Daggett was a major figure in the early history of Fort Worth as a city booster, legislator, and merchant. He donated 96 acres for the construction of the Texas & Pacific Railroad depot. (Courtesy of Tarrant County College District Archives.)

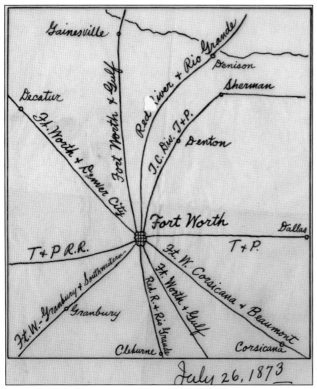

Capt. B.B. Paddock, the editor of the *Fort Worth Democrat*, made a map in 1873 showing Fort Worth to be the central node in a railroad network. Speculation about the future of Fort Worth was running at a fever pitch given the spectacular coup the city had in netting a railroad depot on a major transcontinental. When *Philadelphia Chronicle* editor John Forney published a pamphlet, "What I Saw in Texas," which excited crowds in the Northeast about the possibilities out in the Southwest, land prices began to boom, and merchants began flocking to Fort Worth, bringing the population up to an estimated 2,000 souls. (Courtesy of University of Texas at Arlington Library.)

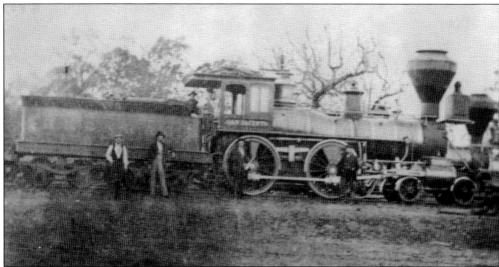

However, that year, the Crédit Mobilier scandal set off the great Panic of 1873, which caused an economic depression throughout the United States. The Texas & Pacific stopped only a few miles east of Fort Worth at Eagle Ford as the financial backer for the T&P project, Jay Cooke & Company, declared bankruptcy. This train in Longview would have been a tempting sight for the eager eyes of Fort Worth, which had to endure an excruciating three-year wait. Eventually, the citizens of Fort Worth would take the matter into their own hands and organize the completion of the track in order to prevent the state from terminating the contract. By September 2, 1876, the city would have its first railroad station. (Courtesy of Longview Public Library.)

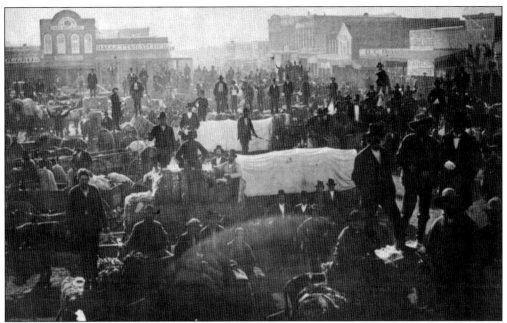

The railroad opened up Fort Worth to be more than just a stopping point for cattle herds. By the mid-1870s, buffalo hides from Fort Griffin were moving through the city along with cotton, seen above. In fact, the city rivaled Wichita, Kansas, for the West Texas market. The marketplace transformation of Fort Worth not only brought business but also changed the local economy from a barter system of exchange to using cash. Housing shortages caused an estimated 1,000 Fort Worth citizens to sleep in tents around the city. (Courtesy of Fort Worth Public Library.)

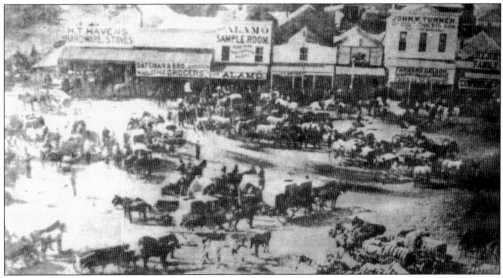

The city of Fort Worth was little prepared for the boom that the railroad brought. In this photograph, the number of wagons casts the image of a disorderly street with little sense as to where traffic should go. Businessmen arrived and opened up a number of different storefronts to cater to the growing needs of the community. Fort Worth moved rapidly to modernize along with the railroad but understandably had trouble keeping up with paved streets. (Courtesy of Fort Worth Public Library.)

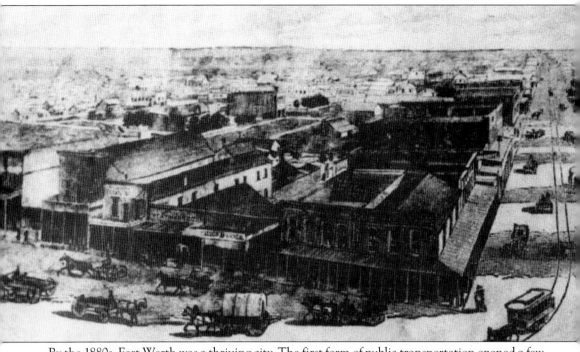

By the 1880s, Fort Worth was a thriving city. The first form of public transportation opened a few days after Christmas 1876. Two mule-drawn cars transited across town for 5¢. In the following years, stagecoaches, carts, pedestrians, and horses would vie for space in the crowded streets. Gas lamps

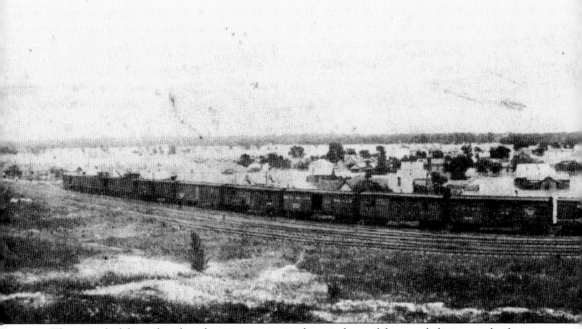

The arrival of the railroad made a connection in the mindsets of the people living on the frontier that they were no longer just an outlier to American cities, politics, and culture radiating from the eastern seaboard but connected to them. This undated photograph looks eastward from Second

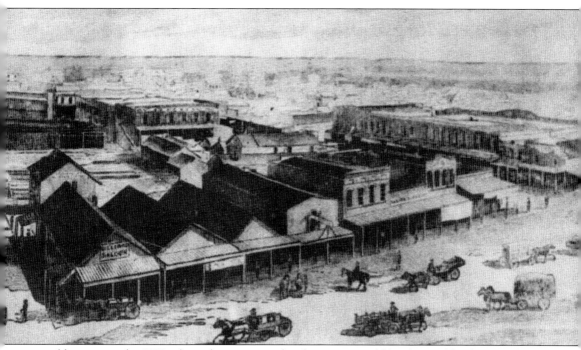
would appear in the 1870s along the streets, and architecture would be changed by the arrival of building supplies from the eastern United States. (Courtesy of Fort Worth Public Library.)

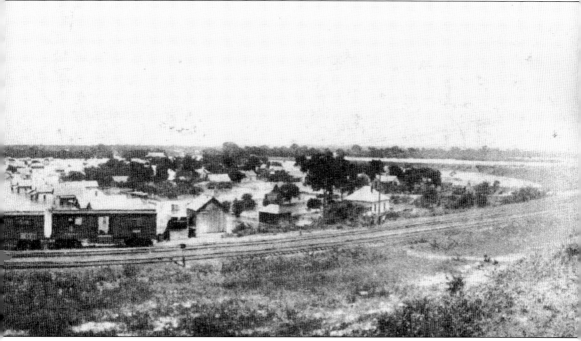
Street in Fort Worth and captures the young town against the backdrop of the prairie. (Courtesy of Fort Worth Public Library.)

The telegraph arrived in Fort Worth in September 1874, well ahead of the railroad. This 1881 photograph of the Southwestern Telegraph and Telephone Company Building on East Second Street shows some of the markings of a changed city from the previous decade, as full three-story buildings can be seen downtown. The telegraph was as transformational for transmitting information to the city as the railroad was in transporting people and goods to Fort Worth. The poles and wires allowed the city to be connected with the rest of the young and growing nation. (Courtesy of University of Texas at Arlington Library.)

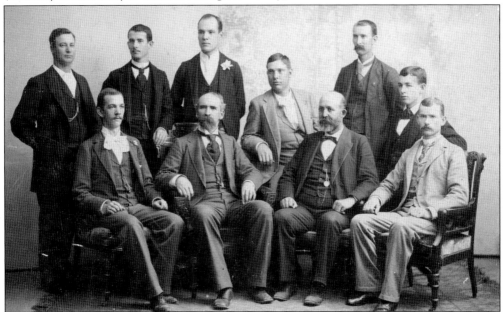

Ten employees of the First National Bank of Fort Worth pose for a photograph in 1893. Though the first banks emerged in Fort Worth in the early 1870s, the First National was destined to become the oldest bank in the city, being incorporated in January 1877. While the city awaited the railroad during the years 1873–1876, several banks struggled to thrive in the city. After the arrival of the railroad, the banks enjoyed soaring profits, prompting the First National Bank to declare a 12-percent dividend at the end of the year in 1877. (Courtesy of University of Texas at Arlington Library.)

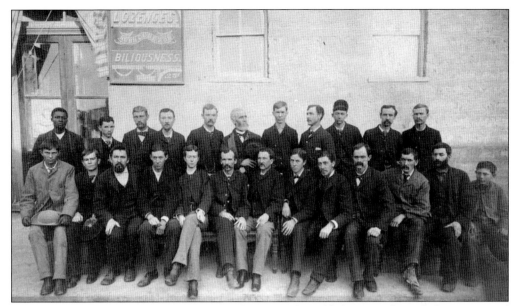

With the completion of the railroad, citizens of Fort Worth could obtain much-needed groceries, and wholesale stores like the Williams's Wholesale Drug Company met those needs. The advertisement in the upper left corner of the photograph advertises for "purgative lozenges." Hardware, books, silverware, farming equipment, boots, furniture, clothing, dry goods, pianos, sewing machines, lumber, hats, and coffins all became readily available either on hand or on order in the burgeoning city that exponentially increased its demands for all the benefits that came along with modernity. (Courtesy of University of Texas at Arlington Library.)

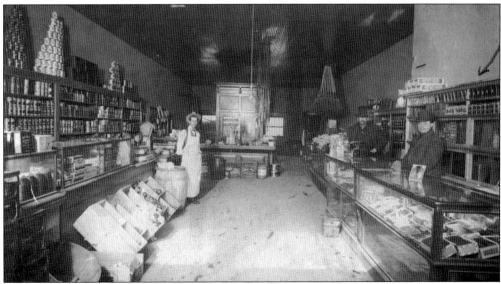

An undated photograph of the general store a block east of the courthouse in Fort Worth depicts the typical goods found in the store. The railroads brought much of these goods and allowed for a prosperous mercantile section of the city to grow. A famous Scottish wholesaler, Joseph Brown, opened a store in Fort Worth in 1876 and became known as the "merchant prince of Northwest Texas" when his 1883 sales in the region exceeded $1,850,000. (Courtesy of Tarrant County College District Archives.)

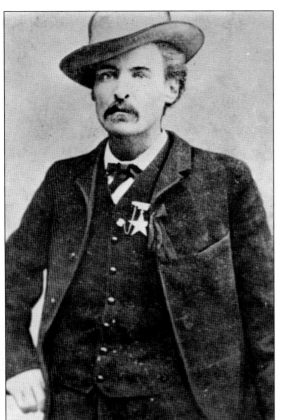

Of course, the spectacular growth and prosperity did not come without some of the downsides of becoming a city. Crime became an increasingly larger problem in the late 1870s and was particularly acute in the section of Fort Worth between Commerce and Calhoun Streets, Hell's Half Acre. Saloons, gambling, and prostitution became a problem as the Chisholm Trail traffic increased with the cattle drives, and the railroads had brought some of the more famous and infamous characters of the Wild West to Fort Worth's doorsteps. In one of the more famous incidents, Fort Worth marshal Jim Courtright (left) was gunned down by a gambler and saloon manager, Luke Short, in a gunfight in north Fort Worth. Short was found not guilty based on self-defense, and it was thought that Courtright was attempting to run a protection racket. (Courtesy of Tarrant County College District Archives.)

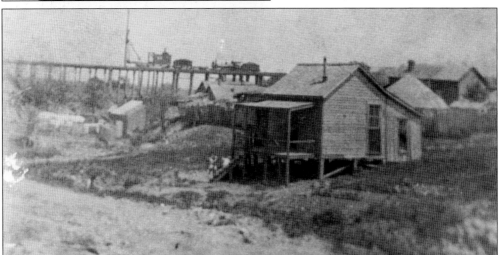

As the T&P stretched westward, Fort Worth needed more linkages to place it astride commerce networks running east-west and north-south. The Missouri–Kansas–Texas (Katy) Railroad arrived in Fort Worth in 1880. By 1882, the Santa Fe came from Cleburne to link up in Fort Worth. Three Fort Worth railroads (the Fort Worth & Denver City, Fort Worth & New Orleans, and Fort Worth & Rio Grande) followed. This image of Fort Worth shows a Santa Fe train and trestle in the distance; the train is making its way through the town in the 1880s. (Courtesy of Tarrant County College District Archives.)

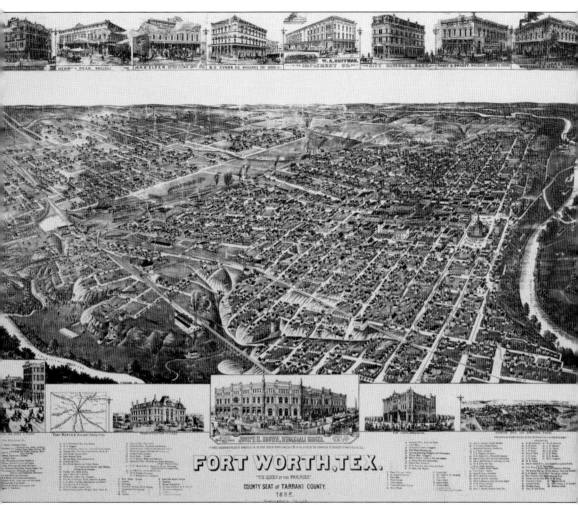

By 1886, the city was growing so rapidly that it could afford to boast a little. Its railway, churches, banks, courthouse, and college gave it the image of a model American community of its day. By this time, Fort Worth had wrestled the county seat away from Birdville and was advertising itself as the "Queen of the Prairies." Just 10 years prior, the famous story spread of a panther that was found sleeping in the middle of town, but Fort Worth had made great strides since then, thanks to the arrival of the railroad. (Courtesy of University of Texas at Arlington Library.)

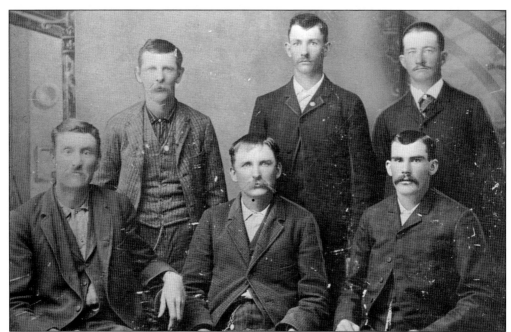

The Texas & Pacific foremen who constructed the connection between the main line and Sherman, Texas, are pictured in 1890. The T&P was expanding branch lines to connect with local communities to further expand its operations. Constructing the railroad was a hard job that these men performed with a high degree of precision. Pictured are, from left to right, (sitting) B. Price, J. Wiggs, and John McLamore; (standing) William Ballew, T. Flynn, and Joe Boston. (Courtesy of University of Texas at Arlington Library.)

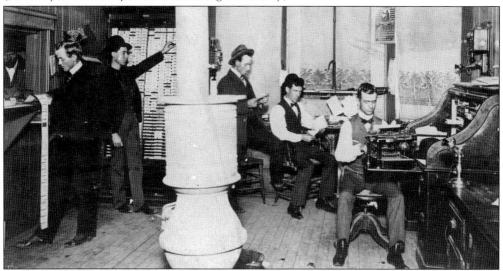

These Fort Worth & Denver City Railroad office employees in Childress are busy at work in this undated photograph. The railroad offices were equipped with the most modern of telecommunications technology to transmit vital information along the railroad line. The railroad office employees had to be efficient and monitor the latest developments that could hinder the arrival or departure of supplies and passengers between stations along the railroad. (Courtesy of Childress County Heritage Museum.)

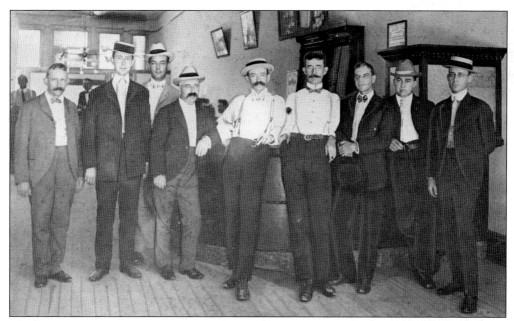

These Texas & Pacific ticket agents of a later era display a very stark contrast with their earlier counterparts in Childress, Texas. Given the more relaxed impression of railroad employees, the changing fashions and trends were transforming the customs and traditions of Fort Worth. By this point, Fort Worth had become less of an outpost and more of a cosmopolitan city. (Courtesy of University of Texas at Arlington Library.)

Even as late as 1902, railroads were still constructing routes to Fort Worth, as surveyors in this photograph from the Chicago, Rock Island & Gulf Railway work on a 10-mile section of railroad between Dallas and Fort Worth. Though the Rock Island had been arriving since 1893, the railway had acquired several smaller railways and was constructing routes southward from the Midwest and westward to the eastern half of the Southwest. The city of Irving would be founded during the construction of this section of railroad, showing that even nearly three decades later, the railroad was contributing to the development of the Dallas–Fort Worth region. (Courtesy of Irving Archives.)

The Rock Island survey team that came to complete the section was part of a larger Rock Island project constructing the routes that would become later known as the Mid-Continent Route. The Rock Island would prompt the creation of Irving and Hurst, communities along the track between Dallas and Fort Worth, around the turn of the century. (Courtesy of Irving Archives.)

This photograph is of William Letchworth Hurst, who was originally from Tennessee and owned a farm near Bedford, Texas. He allowed the Rock Island Railroad to build across his land, and he founded Hurst, Texas. The train depot in Hurst was named after him. (Courtesy of Tarrant County College District Archives.)

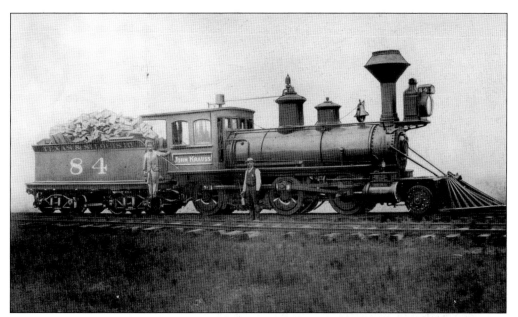

Some of the earliest locomotives used wood-burning engines. Wood, coal, or oil could be burned to produce steam in the boiler that drove the steam engine. This undated photograph is of the *John Krauss*, or "Cotton Belt," train, which was operated by the Texas & St. Louis Railway in Tyler, Texas. This was one of the earlier trains to be seen in Texas when the railroad first came into the state. (Courtesy of University of Texas at Arlington Library.)

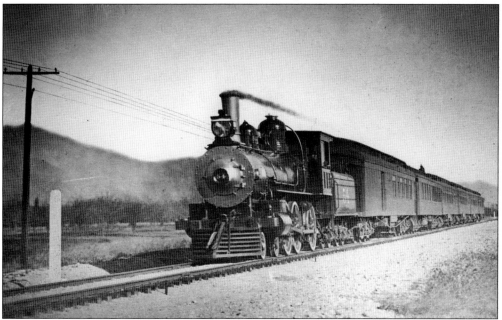

This early photograph is of the Santa Fe Railroad's *California Limited* entering Los Angeles sometime in the late 1870s. This 4-6-0 locomotive transiting over a wooden railway was an early pioneer piercing westward in this age of expansion for the industry. The 4-6-0 locomotive engine replaced the 4-4-0 and was prevalent throughout the 1860s and 1870s. (Courtesy of Museum of the American Railroad.)

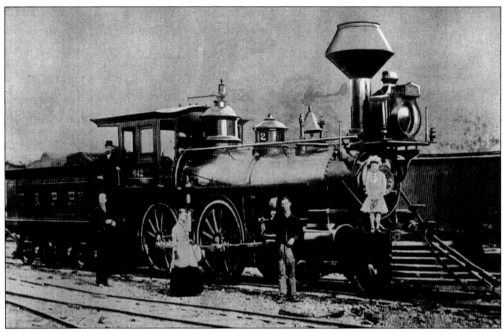

The excitement over the arrival of the railroad prompted families to celebrate it as a marker of progress and civilization coming to the distant frontiers. This very early image from 1876 shows a Texas family in front of a Texas & Pacific Railroad locomotive. (Courtesy of University of Texas at Arlington Library.)

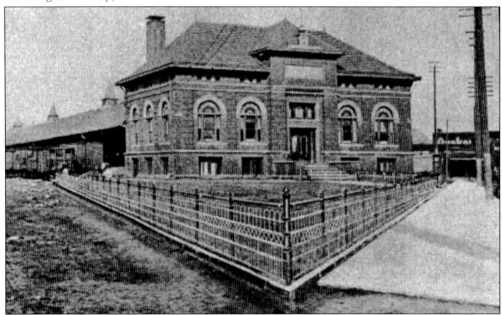

The construction of a railways station was the first step in connecting a community with the greater national economy. The Texas & Pacific Railroad constructed this railway station in Fort Worth to give citizens a central building handling a regular level of traffic. A station the size of this one in an image from 1900, however, could not compare with the larger T&P stations that would be constructed in the following decades. (Courtesy of University of Texas at Arlington Library.)

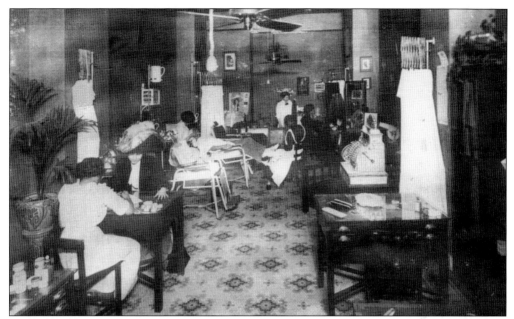

As elsewhere, fashions that arrived in Fort Worth could be provided with the railroads making regular deliveries of stocks and goods. Citizens of Fort Worth could monitor and keep apace of the latest trends, and storefronts quickly sprouted up to meet their needs and desires. In this image from the late 19th century, lady customers are patronizing a hair and fashion store in Fort Worth. (Courtesy of Fort Worth Public Library.)

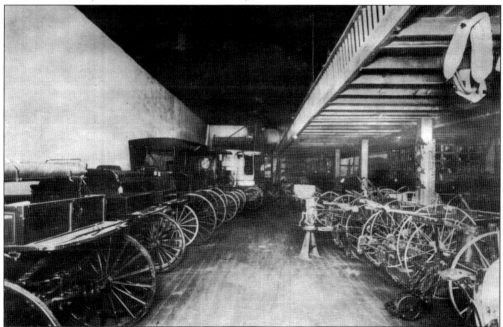

Before the automobile made its appearance in Fort Worth, carriages were the predominant form of street travel for small groups of people. A carriage business had to have a wide floor to show off the various options for customers. In this image, a carriage store in Fort Worth shows several options of covered and uncovered carriages. (Courtesy of Fort Worth Public Library.)

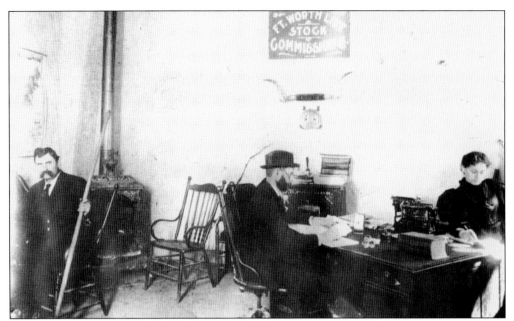

Livestock exchanges quickly centered on Fort Worth soon after the railroad arrived. By 1889, the Union Stockyards were operating a few miles north of the Fort Worth Courthouse. This small operation was soon insufficient to meet the demands of the booming livestock market of Fort Worth, and plans would soon center on the construction of the building still standing. In this undated photograph, the livestock commission is seen in action close to the turn of the century. (Courtesy of Fort Worth Public Library.)

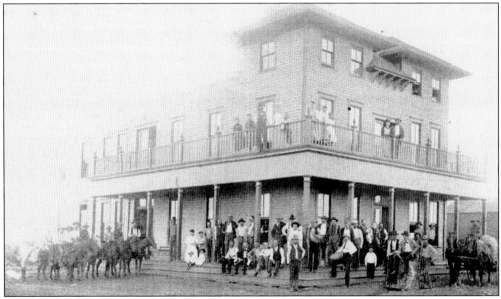

The hotel business boomed in the wake of the railroad as passengers naturally needed to find lodgings in their travels. With Fort Worth a rapidly growing city, the hotels were in stiff competition for travelers and businessmen and newly arrived workers. In this image, a Fort Worth hotel is seen with people standing in front around the turn of the century (Courtesy of Fort Worth Public Library.)

Two
BECOMING A CITY

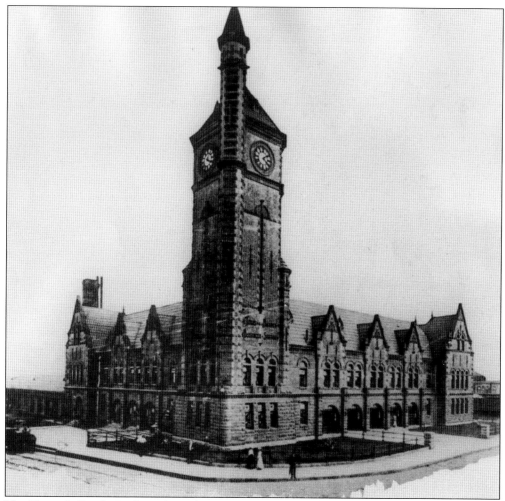

The Texas & Pacific Railway depot became a proud center of Fort Worth when it was built in 1900 on Main and Front Streets. The stone depot had a beautiful interior and a large tower that loomed over the city. During the previous three decades, Fort Worth had enjoyed an enormous economic and demographic boom largely thanks to the railroad and the enthusiastic spirits of the city. (Courtesy of Tarrant County College District Archives.)

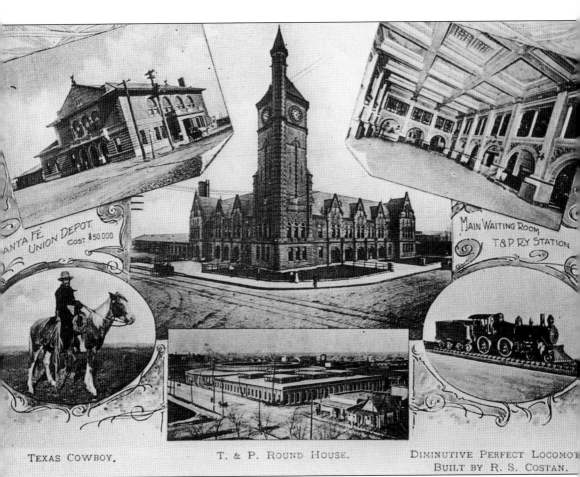

This photograph from around 1900 shows a blend of imagery that Fort Worth embraced. In the upper-left corner is the newly constructed Santa Fe depot; the bottom left features a Texan cowboy, which pays heed to the legacy of the city; the center image on the bottom is T&P roundhouse building; the lower right is a locomotive design by R.H. Costans; and the upper right is the T&P main lobby. (Courtesy of University of Texas at Arlington Library.)

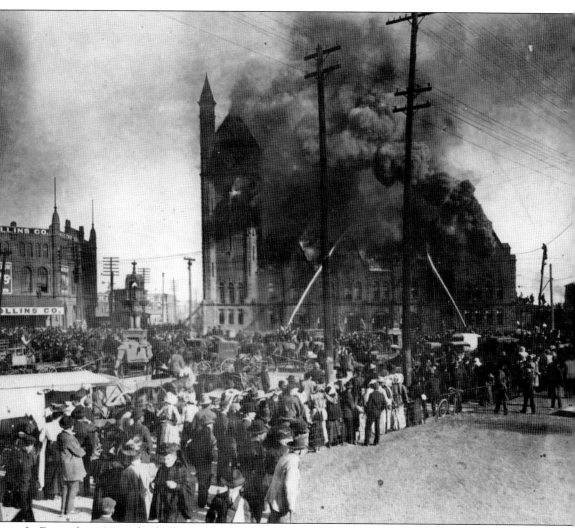

In December 1904, a fire broke out that destroyed the majestic building and cost the T&P about a quarter of a million dollars. The depot was reconstructed afterwards and would remain standing until it was taken down in 1931 and replaced by a much larger depot at East Lancaster Avenue and Main Street. (Courtesy of University of Texas at Arlington Library.)

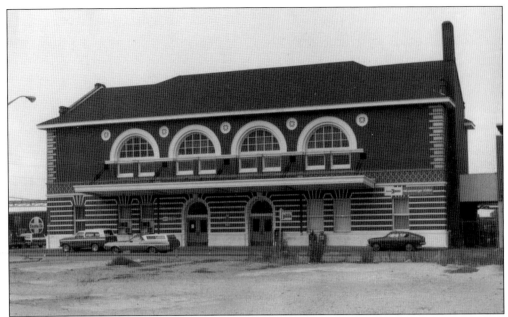

The Santa Fe Railroad depot was built in 1899, and while always second-place next to the T&P station, the Santa Fe remained one of the famous landmarks of the city for many years to come. (Courtesy of Tarrant County College District Archives.)

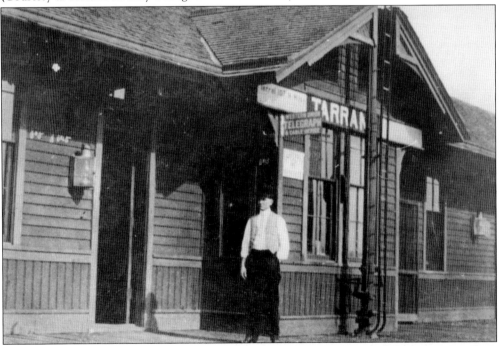

The Rock Island Railroad had a small depot in Euless, Texas. In one of the instances where plans did not go as expected, Rock Island built a depot in the area thinking it was ripe for a commercial boom. The area may have reached a population of 100 by the end of the 1920s, but this was not enough, and it closed the depot in 1930. (Courtesy of Tarrant County College District Archives.)

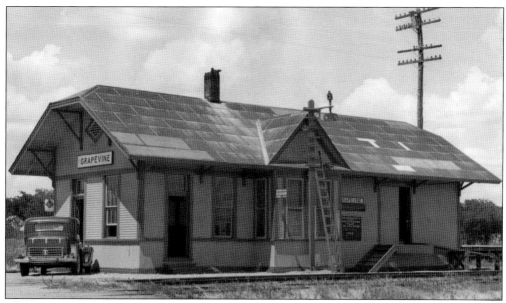

The St. Louis Southwestern Railway Company, otherwise known as the Cotton Belt, arrived in Fort Worth in 1887, and this depot was built the following year with cotton docks. The original design of the railroad was to connect the cotton-growing regions of Arkansas and Texas to the St. Louis marketplace for sale. However, the main lines in Texas proved to be mostly unprofitable with the exception of a depot in Grapevine, Texas, which today can still be seen, as it has been preserved as the Grapevine Heritage Center. (Courtesy of Tarrant County College District Archives.)

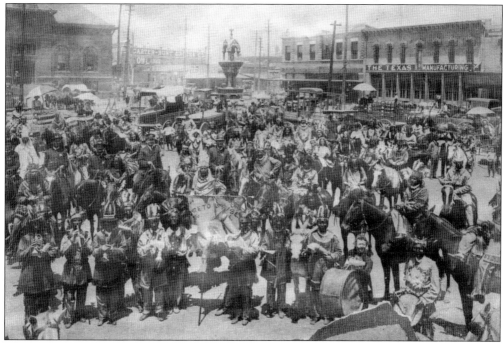

The Texas & Pacific Railroad yard provided a convenient meeting place for organized activities in the Fort Worth area. This Order of Red Men meeting occurred in 1900 in the T&P Railroad yard. (Courtesy of Fort Worth Public Library.)

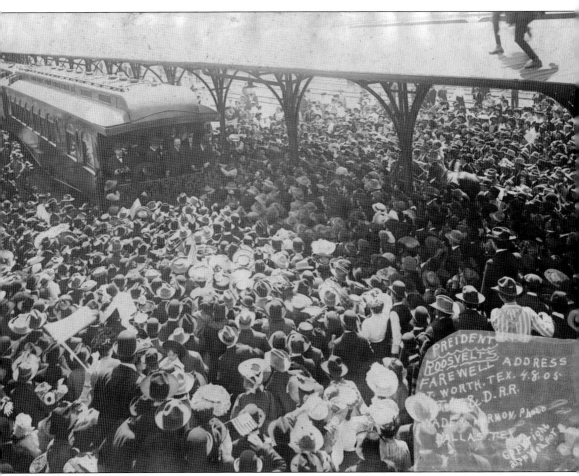

On April 8, 1905, Pres. Theodore Roosevelt stopped in Fort Worth to deliver a farewell address. The occasion was one of the most important that the young town had experienced up to that point, and the speech was delivered from the president's mode of transport along the nation's railways. An estimated 20,000 people greeted Roosevelt at the T&P station, and he made a return visit in 1911. The roof of a nearby building collapsed under the weight of a crowd of onlookers without anyone being injured. (Courtesy of University of Texas at Arlington Library.)

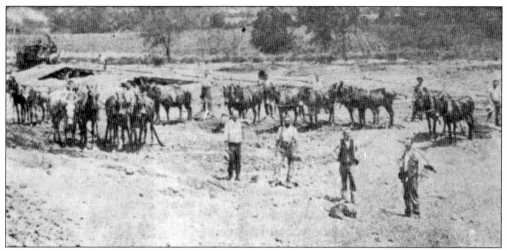

In 1901, ground was broken for the construction of the Armour and Swift Meatpacking Company. The legacy industry of cattle herding was a proud tradition in the city still referred to as "Cowtown," but the meatpacking industry would add to that tradition. (Courtesy of Tarrant County College District Archives.)

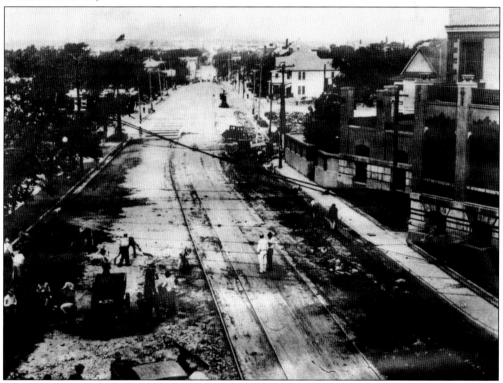

The railroads could connect cities and far-flung regions together, and the same technology could be used to construct local transportation networks. This image shows the construction of the Fort Worth Street Railroad car tracks. The scope of the Fort Worth Street Railway Company was small, as it ran a line for one mile down Main Street in Fort Worth with mule-drawn carts. The two carts made about 160 trips per day and moved about 440 passengers. (Courtesy of Fort Worth Public Library.)

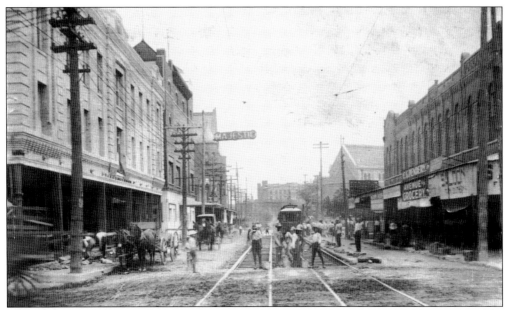

Electrification of the lines began after 1889, and many competing lines would emerge and be acquired by the Fort Worth Street Railway Company until the Bishop and Sherwin Syndicate renamed the enterprise Northern Texas Traction Company in 1901. The Northern Texas Traction Company gave citizens a chance to travel between Dallas and Fort Worth. However, the line needed to be constantly repaired, as in this instance between 1907 and 1911. These workers received low wages but worked hard to keep the line running. (Courtesy of Fort Worth Public Library.)

The electrification of the Northern Texas Traction line necessitated the building of an interurban infrastructure that included this powerhouse in Handley capable of generating enough electricity to power the cars transiting between Dallas and Fort Worth. (Courtesy of Tarrant County College District Archives.)

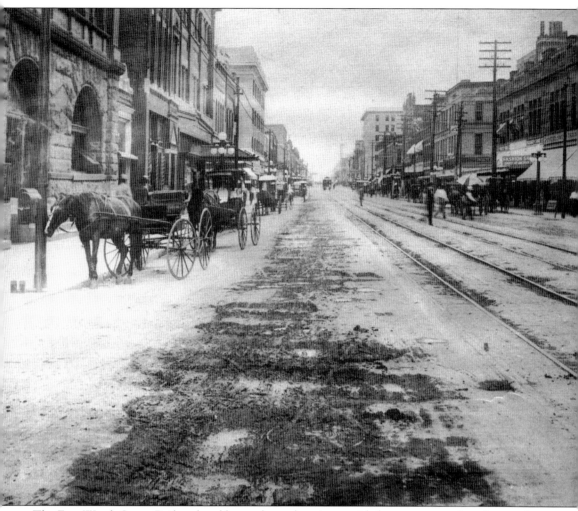

The Fort Worth Street Railroad and horse-drawn buggies provided passengers options for travel throughout the city. As this photograph from 1900 shows, streets could have three different kinds of transportation. At times, the road could become very congested with a mixture of carts, interurban cars, horses, and pedestrians crowding the streets. Only with the coming of the automobile would one mode become predominant in Fort Worth. (Courtesy of Fort Worth Public Library.)

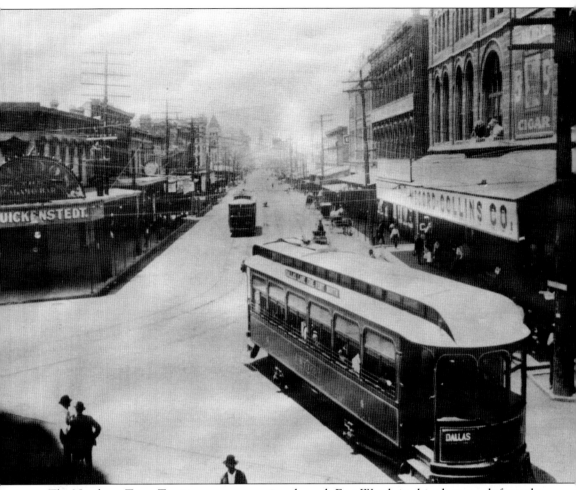

The Northern Texas Traction cars are moving through Fort Worth in this photograph from the early 1900s. The car in front advertises the Dallas–Lake Erie–Fort Worth line that it transits along and is likely going to Dallas based on the sign at the front. Lake Erie was where the company had a trolley center with a pavilion and recreational activities for visitors. The Northern Texas Traction Company would continue to provide passenger service until 1934, when the company ceased to operate due to an antitrust suit and diminishing profits. (Courtesy of Fort Worth Public Library.)

A bicyclist on Houston Street looks northward at the electrified cars of the Northern Texas Traction Company and an ever-increasingly busy downtown Fort Worth. The street railroad and the commerce brought by the railroads that arrived in preceding decades had visibly transformed the town by the time this photograph was taken sometime around 1900. Gun stores, theaters, and even Coca-Cola advertisements make up the cosmopolitan landscape that had changed Fort Worth since the railroads' arrival. (Courtesy of Fort Worth Public Library.)

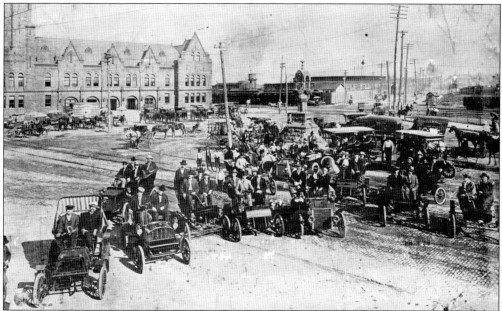

The automotive era of Fort Worth began with a meeting of 15 "horseless carriages" in front of the T&P station in the summer of 1903. Though these early automobiles were scarcely competitors with the railroads, their descendants would eventually not only dominate the streets of Fort Worth but would also redirect passenger traffic and transform the city in the coming decades. (Courtesy of Fort Worth Public Library.)

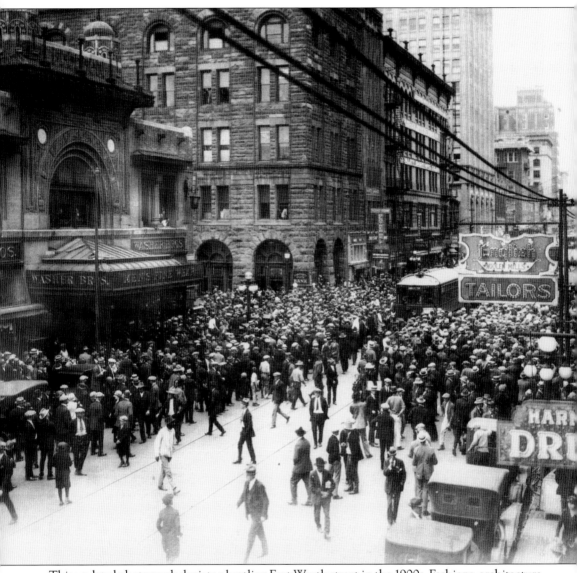

This undated photograph depicts a bustling Fort Worth street in the 1900s. Fashions, architecture, and the businesses had modernized in the course of several decades, and the city was a far cry from when it earned its moniker "Panthertown." (Courtesy of Fort Worth Public Library.)

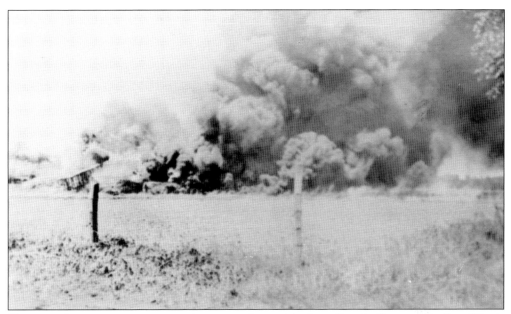

Train wrecks were an occurrence that went along with the railroads. Fortunately, Fort Worth has not experienced any of them, though they have happened close to town. In the early 1920s, this train wreck occurred along Highway 121 southwest of Grapevine. This was a train that was moving along the Cotton Belt line. (Courtesy of Tarrant County College District Archives.)

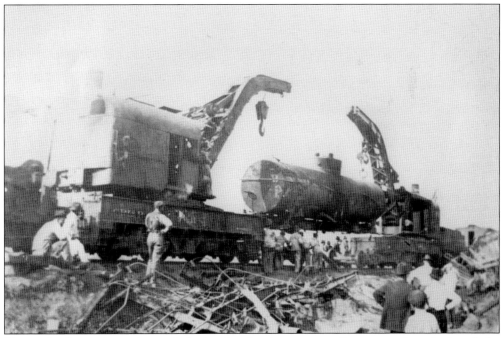

Here is the Grapevine train wreck during the cleaning-up stage. Cranes were brought in to help. Railroads could usefully bring heavy equipment like these cranes despite their overwhelming load. (Courtesy of Tarrant County College District Archives.)

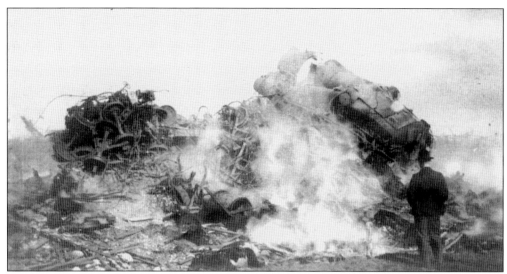

Whenever a train derailed, its weight and velocity could cause it to crumple up into a smoking pile of debris. Derailments could occur for a variety of reasons: misaligned or damaged track, the train being flung from the track by its volume and velocity, or an obstruction that caused the train to bounce off the track. Trains were always very dangerous because they could experience such violent accidents. In this photograph, one onlooker stares at the wreckage. (Courtesy of Fort Worth Public Library.)

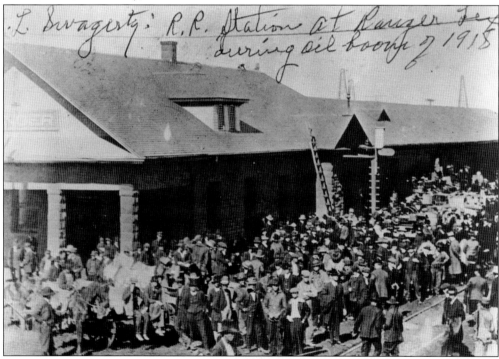

The oil booms that would add yet another industry to the Texas economy would change the landscape as much as railroads had in previous decades. In this photograph, crowds gather in Ranger, Texas, during the 1918 oil boom. Similar booms would happen throughout Texas in the ensuing decades. (Courtesy of University of Texas at Arlington Library.)

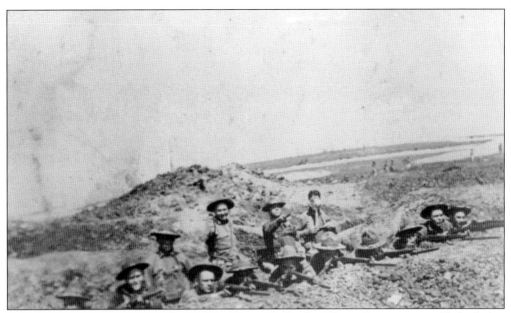

World War I saw the return of the US Army to Fort Worth as Camp Bowie was established after the American entry into the war. The military brought soldiers on the railroads to the camp and gave them basic training. In this photograph, soldiers in the 111th Engineers are likely drilling their rifle marksmanship or going through a combat maneuver. (Courtesy of Tarrant County College District Archives.)

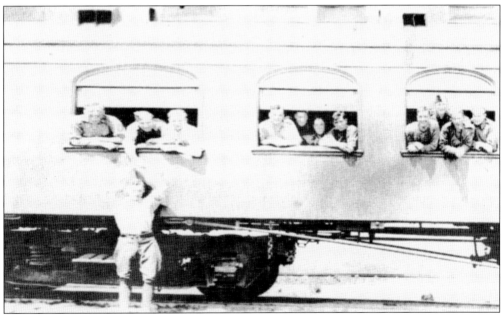

Here, soldiers are enjoying themselves while boarding a train in Benbrook, Texas. (Courtesy of Fort Worth Public Library.)

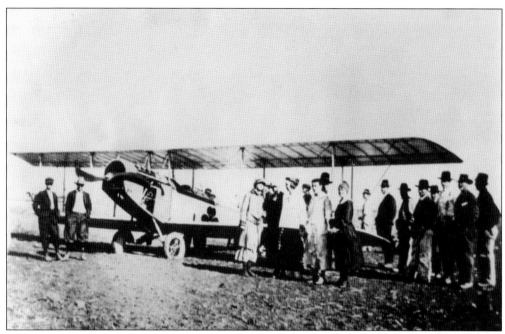

The age of the airplane began in Fort Worth when the aerial daredevil Cal Rodgers flew the first airplane in the city in 1911. The airplane in this photograph arrived in Grapevine after flying from Camp Bowie. Airplanes were obviously no competition when it came to passengers at the early stage, but just as the railroad would become a vital part of Fort Worth history, the airplane would eventually become just as important to the economy of Fort Worth. (Courtesy of Tarrant County College District Archives.)

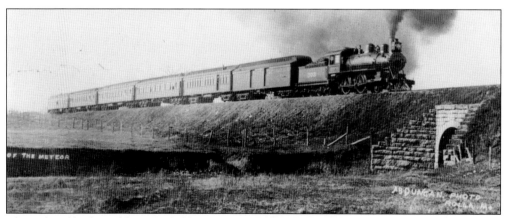

The railroad had steadily and reliably maintained itself as the premier form of transportation all the way up to the 1920s. In this 1910 photograph, the St. Louis & San Francisco's famous passenger train the *Meteor* chugs along a line of track. The passenger train passed between Chicago, St. Louis, Dallas, and Fort Worth. (Courtesy of Museum of the American Railroad.)

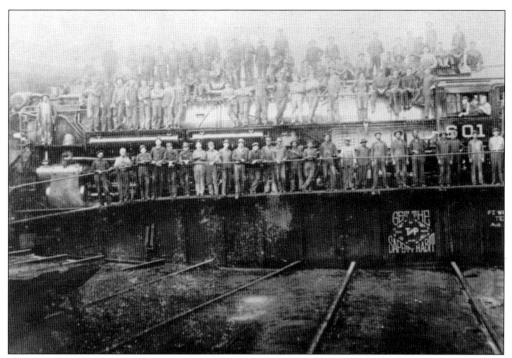

Texas & Pacific Railroad men stand beside a new 600 class locomotive in this 1923 photograph. The railroads had steadily improved locomotive technology over the years. (Courtesy of Tarrant County College District Archives.)

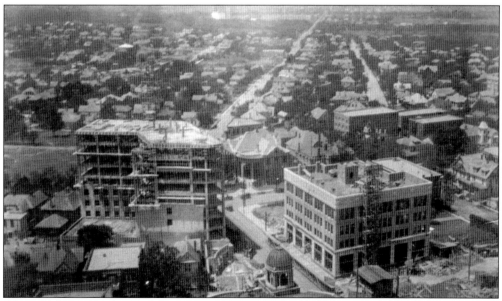

After World War I, the city of Fort Worth was in league with the rest of the vibrant and young American nation. This downtown Fort Worth photograph was taken in 1921 from the Waggoner Building. Suburbs were expanding outward from Fort Worth, and the city was becoming the center of its own larger community. (Courtesy of Tarrant County College District Archives.)

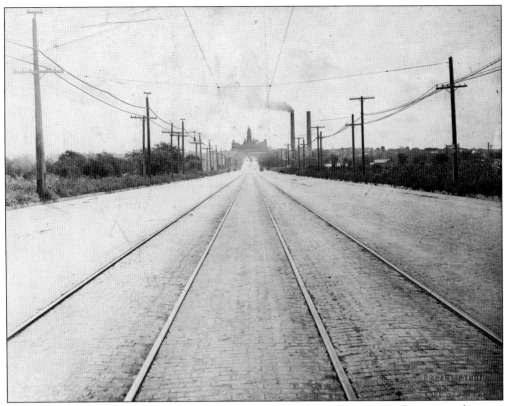

The convenience of traveling by an interurban railroad can be seen in this image showing the courthouse in Fort Worth in the distance. This image shows a view across the interurban railroad tracks along North Main Street in Fort Worth in 1914. (Courtesy of University of Texas at Arlington Library.)

The Fort Worth Livestock Exchange Building was built in 1902 to provide a facility focused on cattle transactions. The building would become a major historical landmark in the ensuing decades besides being a critical economic center. This image shows the stock pens with the Fort Worth Livestock Exchange Building in the background. (Courtesy of Tarrant County College District Archives.)

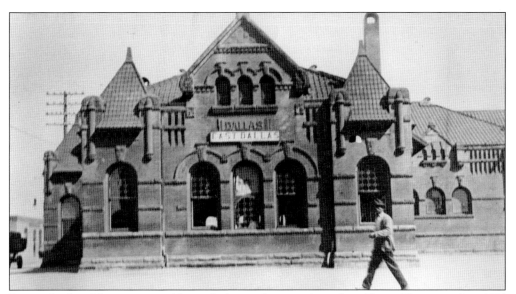

Regional railroad depots were emblems of a frontier heritage throughout Texas. This image from 1916 of the Houston & Texas Central (Southern Pacific) depot in East Dallas shows a building that stands out with spires and overlooking windows. (Courtesy of Museum of the American Railroad.)

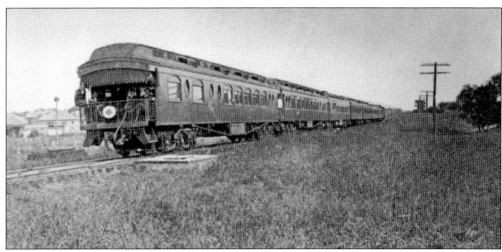

The early era of steam locomotives featured a variety of trains. This Texas & Pacific *Texas-Colorado Limited* train, pictured in 1907, is moving eastward to Dallas and is completely constructed with wood. This train is an early example of wooden passenger trains found on the railroads in the initial period of the age of steam. (Courtesy of Museum of the American Railroad.)

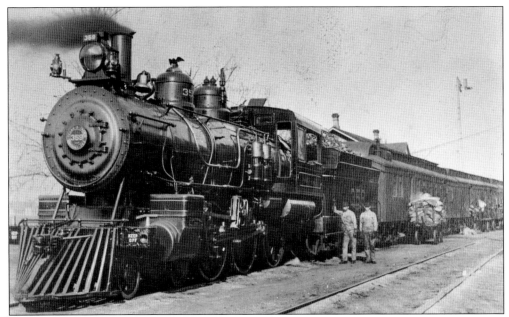

The Texas & Pacific Railroad's *Cannon Ball* carried Pres. William Taft on a 1909 tour of Texas where he gave speeches similar to his predecessor. In this image from the fall of 1903, the eastbound *Cannon Ball* train is at the depot in Marshall, Texas. (Courtesy of Museum of the American Railroad.)

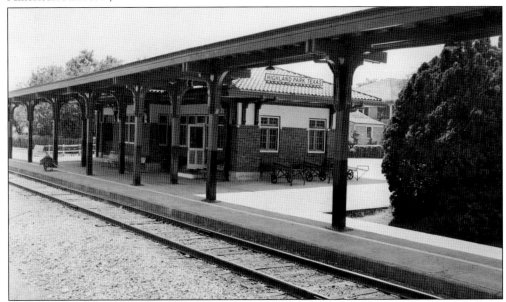

The architecture of railroad depots in some ways reflects the changes going on in landscapes and communities the railroads served. In this July 1922 image, the Missouri–Kansas–Texas (Katy) Railroad's new Highland Park depot in Dallas has just been opened and is a marked contrast to the image of the Southern Pacific's East Dallas depot from 1916 with a smaller, nimbler building with lower roofs. This building was not constructed with the intent of standing over the landscape like many railroad depots were in previous decades. (Courtesy of Museum of the American Railroad.)

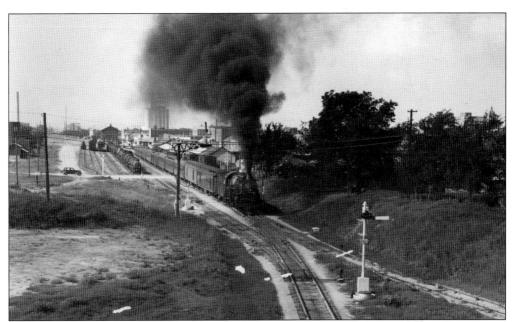

This photograph shows the Santa Fe Railroad's *Ranger* service moving north after passing through Ardmore, Oklahoma, in June 1916. The *Ranger* ran between Chicago and Galveston, Texas, and was a counterpart route to Santa Fe's *Texas Chief* when that service opened in 1948. The route was very busy during World War I and afterwards. (Courtesy of Museum of the American Railroad.)

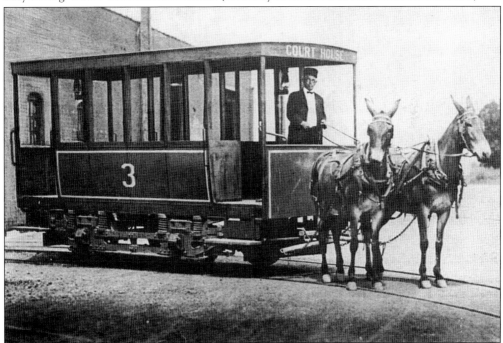

The Fort Worth Courthouse was the most important and prestigious civic building of the city of Fort Worth in its early years. Public transportation like the interurban service in this undated image focused on transiting passengers to and from the courthouse. (Courtesy of University of Texas at Arlington Library.)

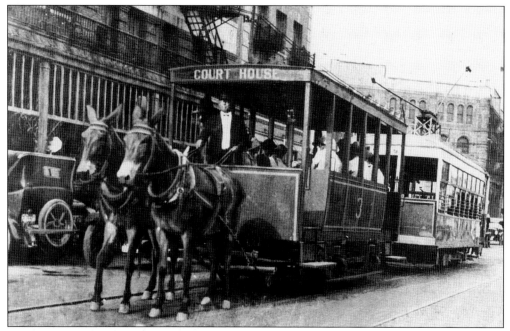

Passenger cars travelled the rail lines that ran along the streets of the city. In this photograph, two mules draw two passenger cars to the courthouse even as an early automobile is visible behind the cars. (Courtesy of University of Texas at Arlington Library.)

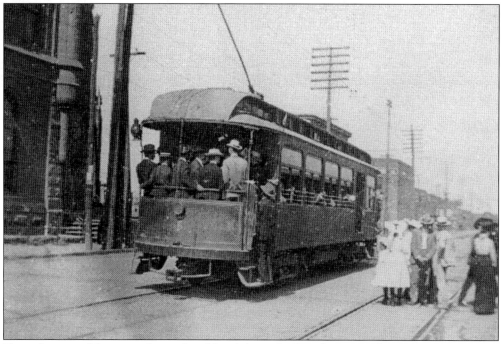

Electrification of the interurban railroad freed the mules from having to drag passenger cars back and forth through Fort Worth. In this image, electrical lines along with telephone poles can be seen in the background. Passenger traffic is obviously dense in this undated image, likely from near the first decade of the 20th century. (Courtesy of University of Texas at Arlington Library.)

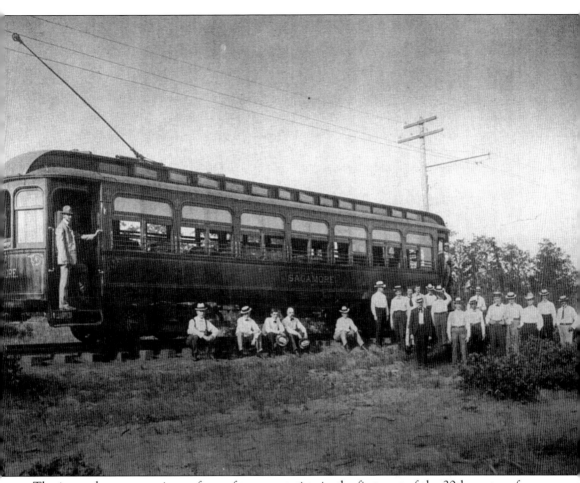

The interurban was a primary form of transportation in the first part of the 20th century for citizens moving from one city to the next. The Fort Worth & Dallas Interurban Railroad had its inaugural run in 1907. In this image, a Sagamore passenger car sits on the tracks with company officials of Fort Worth Traction sitting in front of the car. (Courtesy of University of Texas at Arlington Library.)

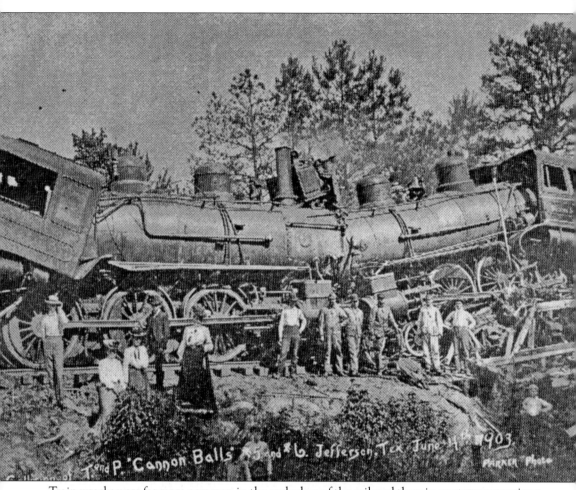

Train wrecks were far more common in the early days of the railroad than in contemporary times. This image shows a devastating head-on crash of locomotives of the Texas & Pacific Railroad on the "Cannonball Run" in Jefferson, Texas. (Courtesy of University of Texas at Arlington Library.)

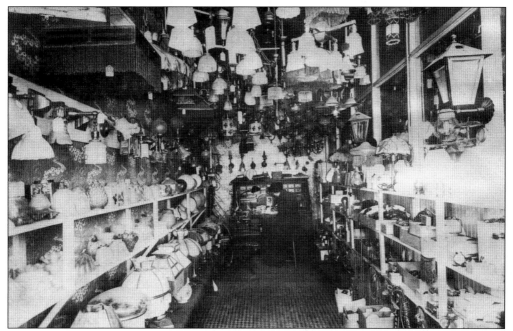

Electrification was an exciting development for Fort Worth citizens, who were previously reliant on fire for light. Electric lights allowed a much brighter and reliable beam for people to continue activities well after dark. In this Fort Worth store, electric lights are on display in various elaborate forms from indoor types of lighting to outdoor lamps. (Courtesy of Fort Worth Public Library.)

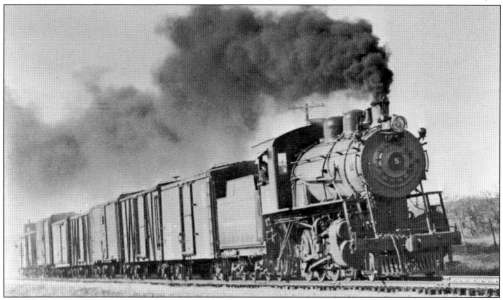

Smaller railroads arrived on the Fort Worth scene along with the larger businesses like the Texas & Pacific Railroad, which would acquire this local railway in 1902. Smaller railroads like the Weatherford, Mineral Wells & Northwestern were chartered to connect communities like Weatherford and Mineral Wells, Texas. In this undated image, a locomotive of the Weatherford, Mineral Wells & Northwestern Railroad moves through Mineral Wells. (Courtesy of Museum of the American Railroad.)

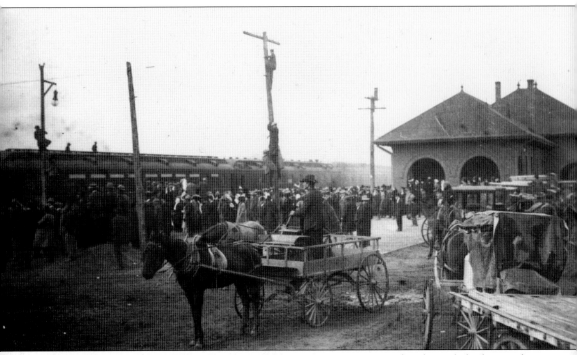

One of the types of employees found around passenger stations were local people looking to bring newcomers to destinations throughout town. These people, known as hacks, usually brought passengers to hotels or saloons or businesses. In this photograph, hacks at a railroad depot in Mineral Wells look for passengers by climbing up poles to provide directions and guidance. People from Dallas–Fort Worth would travel to Mineral Wells during weekends for a spa where they could bathe, relax, and enjoy the natural mineral waters of the area. (Courtesy of Boyce Ditto Public Library.)

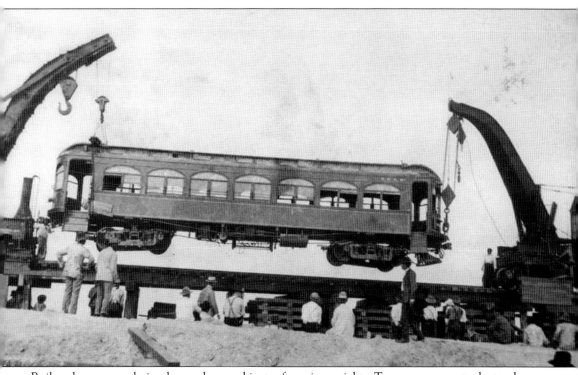

Railroad cars were obviously very heavy objects of varying weights. To move a car onto the tracks, cranes were used. In this image, two cranes in Fort Worth pick up a passenger car while onlookers watch. (Courtesy of Tarrant County College District Archives.)

Following in the wake of pioneer trails and railroad tracks, highways were gradually making their way across America. The first highway to span the nation was the Bankhead Highway, which began in Washington, DC, and stretched westward to San Diego, California. This photograph of the highway in Mineral Wells shows a forerunner to the interstate highways that were to come in the future. (Courtesy of Boyce Ditto Public Library.)

The Bankhead Highway initially began construction in 1916 but was delayed by the onset of World War I. The highway around Mineral Wells was laid with bricks. When it was finally completed, automobiles could travel across the country for the first time along a transcontinental route beside the railroads. In this image, the brick road is shown up close in an area east of Mineral Wells. (Courtesy of Boyce Ditto Public Library.)

Three

PRAIRIE TO POWERHOUSE

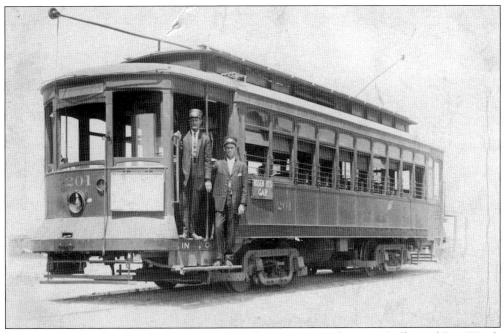

The interurban railroad system was a mainstay of transportation between Dallas and Fort Worth and prospered during the years prior to World War I and the Great Depression. This trolley bears the markings "Rosen Hts Car 201" on the side, standing for Rosen Heights, a real estate development in northern Fort Worth by Sam Rosen, the owner of a clothing store in the city. When his attempt to connect with the main line operated by the Northern Texas Traction Company (NTTC) fell through, he ran his own line parallel to the NTTC's and operated it until the latter purchased his company. (Courtesy of University of Texas at Arlington Library.)

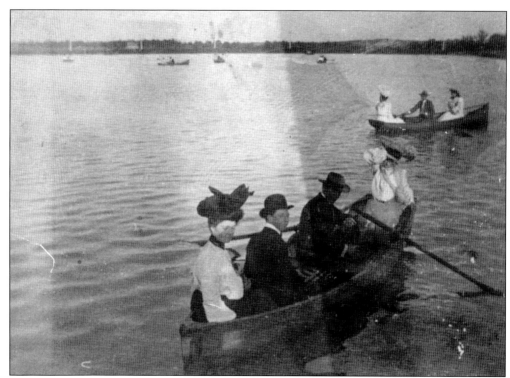

Lake Erie in Handley was just east of Fort Worth, and it was a popular destination for passengers riding the interurban railroad. A pavilion was located at the stop, and a park was nearby where passengers could take boats out onto the lake. As can well be imagined, this was an especially popular site during the summers. (Courtesy of Tarrant County College District Archives.)

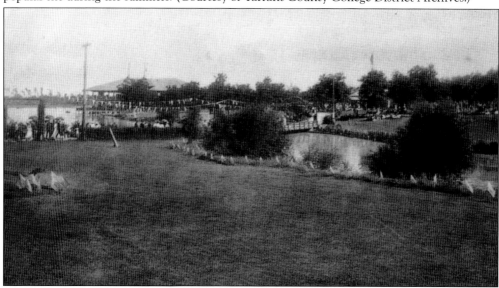

A popular destination, Lake Erie allowed Fort Worth citizens to get out into the country, which could be particularly welcoming on warm summer days. Handley Park had decorations, bridges, and buildings for the public to walk around in. (Courtesy of Arlington Public Library and Fielder House.)

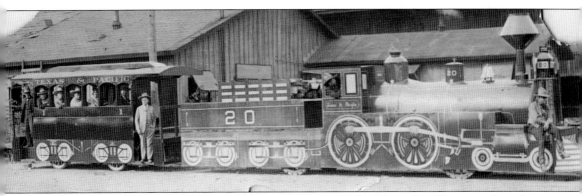

Fort Worth citizens were acutely aware of their frontier past and celebrated it. The particular role that the Texas & Pacific played made it stand above the other railroad lines in the area. Here, a trolley has been dressed up to look like a T&P train in an undated photograph. (Courtesy of University of Texas at Arlington Library.)

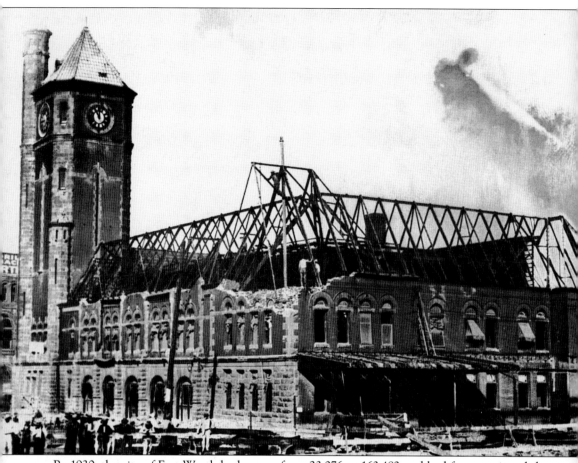

By 1930, the city of Fort Worth had grown from 23,076 to 163,482 and had far outstripped the main railroad depot in town. To prepare for a much more ambitious station reflecting the city's growing size and scope, the old T&P station was torn down. The large old station represented Fort Worth's proud frontier heritage, but as the city grew, T&P had become integrated into the greater American nation and would build a station reflecting this transformation. (Courtesy of University of Texas at Arlington Library.)

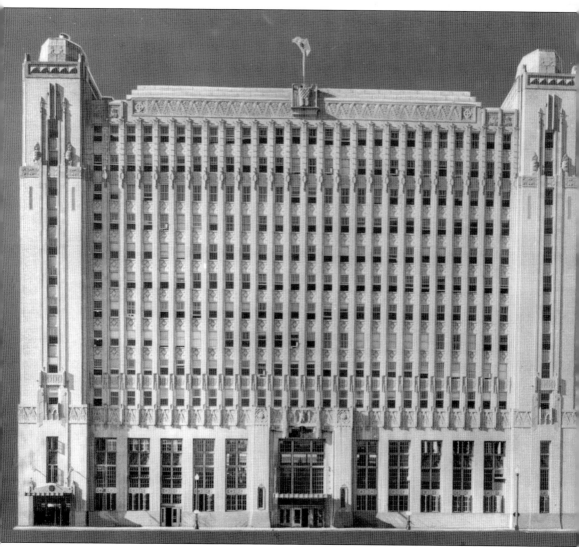

In 1931, the new Texas & Pacific station was constructed on West Lancaster Avenue with an Art Deco architectural style. The architects for the station were Wyatt C. Hendrick and Herman P. Koeppe, who designed numerous buildings across Texas, including eight courthouses. Inside were marble floors and zigzag patterns for interior designs. The building still stands as a historic landmark not only of the architecture of the city but also as a pillar of Fort Worth's place as an American city. (Courtesy of Tarrant County College District Archives.)

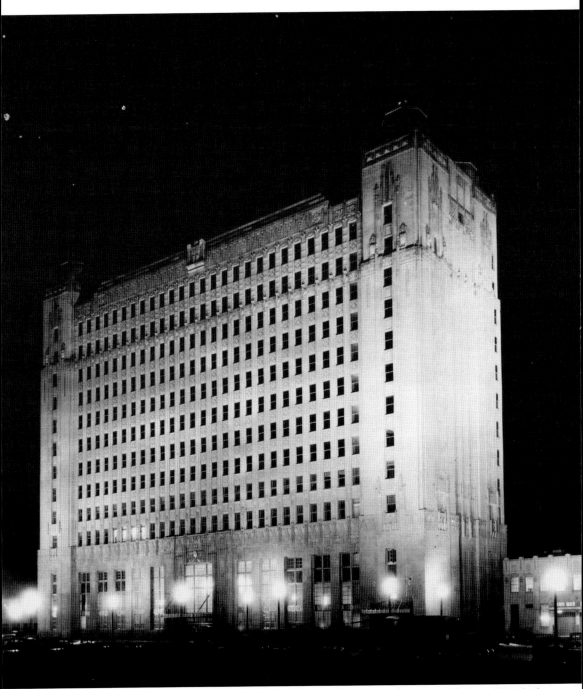

Street lighting had come along at about the same time as the first railroad in Fort Worth, but lighting on the scale needed to light up the T&P station was relatively new to the city. This undated photograph shows that even at night, the city was still alive. (Courtesy of Fort Worth Public Library.)

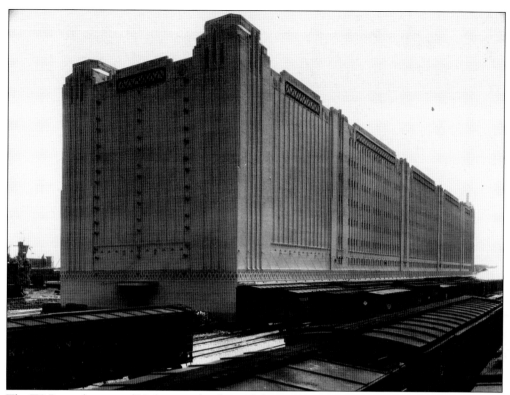

The T&P warehouse and Vickery yards adjoined the great station. During the 1930s, the tonnage largely consisted of agriculture, particularly vegetables and fruits from California, and oil from West Texas. The oil boom provided an increasingly significant amount of freight in the 1920s and 1930s for the Texas & Pacific lines. (Courtesy of Fort Worth Public Library.)

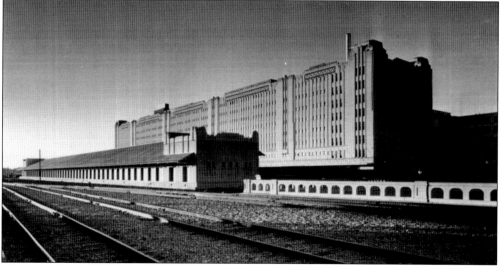

The T&P warehouse was built a block west of the station and is also Zigzag Art Deco style like the main station. Unlike the station, it had refrigeration units for produce along with offices, salesrooms, and other storage facilities. The eight-story, 580,000-square-foot facility had a 611-foot platform for receiving freight. (Courtesy of Fort Worth Public Library.)

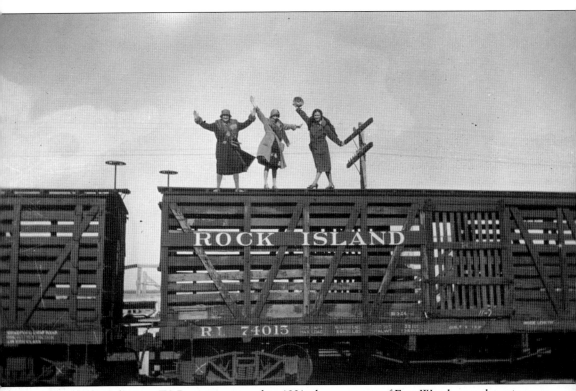

By the time the new T&P station opened in 1931, the economy of Fort Worth was changing yet again. On top of Rock Island cattle cars, a few women wave to the camera. The cattle industry would remain a prominent part of the Fort Worth economy well into the following decades but was gradually being replaced by emerging economic sectors. In 1892, livestock tonnage (1,420,652 tons) was the third largest source of revenue for railroads according to the Texas Railroad Commission, but by 1936, it had slipped to seventh (1,820,510 tons). (Courtesy of Cattle Raisers Museum.)

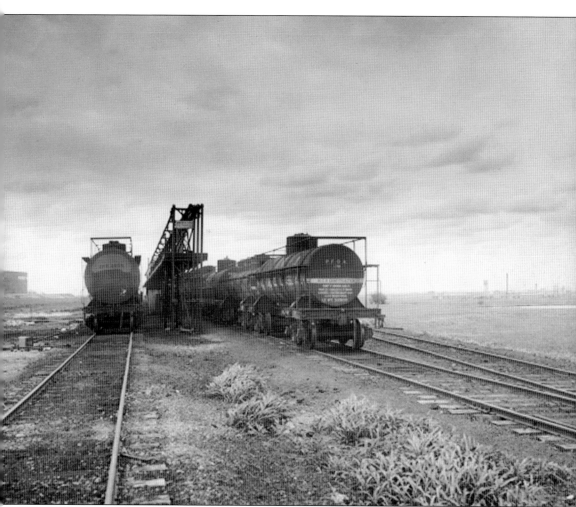

The oil booms from the three big wells (Ranger, Burkburnett, and Desdemona) provided an enormous boost to the Fort Worth economy in the 1920s. By 1922, nine oil refineries were operating in the city as companies and operators moved to Fort Worth. The railroads increasingly shipped oil by rail, as seen in this undated photograph. (Courtesy of University of Texas at Arlington Library.)

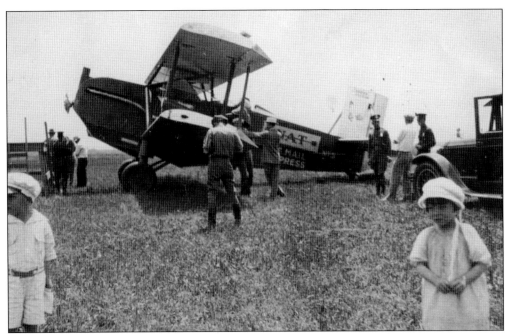

In this photograph, a pilot for National Air Transport is delivering airmail for the first time on a biplane at Meacham Field. The US Army Air Corps in San Antonio was conducting aviation experiments after the end of World War I. Col. Harvey Burwell, along with Sgt. William Fuller, recommended that Fort Worth purchase and establish an airfield north of the city. National Air Transport was a pioneering business in airmail delivery to cities like Chicago and St. Louis. (Courtesy of Tarrant County College District Archives.)

Automobiles had been a novelty in Fort Worth since the early 1900s, but the primitive technology combined with the lack of paved roads in Fort Worth slowed their adoption. By 1909, nearly a thousand cars were registered in town, but as automobiles developed and became increasingly affordable, citizens began to take notice. By the 1920s, automobiles were increasingly present throughout Fort Worth, including the Ford Model T in this photograph that likely was taken sometime in the 1920s or 1930s. (Courtesy of Tarrant County College District Archives.)

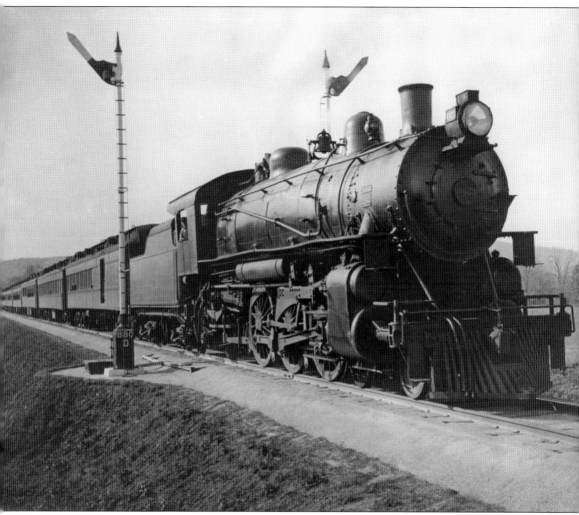

The Missouri Pacific's *Sunset Special* moves through southern Missouri toward St. Louis from Texas in about 1917. The railroads were still the most common form of travel, particularly long-distance. The train is a Pacific-type 4-6-2 locomotive, and as the railroads were steadily facing greater competition from automobiles and aviation, they were about to unveil new designs for passenger travel to keep drawing customers. (Courtesy of Museum of the American Railroad.)

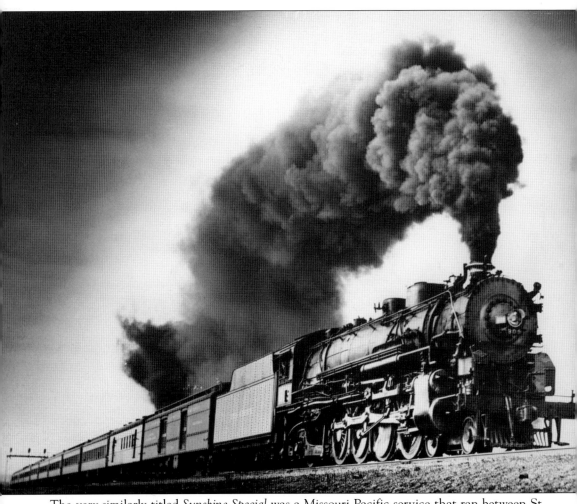

The very similarly titled *Sunshine Special* was a Missouri Pacific service that ran between St. Louis and Arkansas and throughout points in Texas. Here, a 900 class 4-8-2 locomotive moves eastward from Forney, Texas, in the summer of 1929. The T&P operated the line while it ran in Texas. (Courtesy of Museum of the American Railroad.)

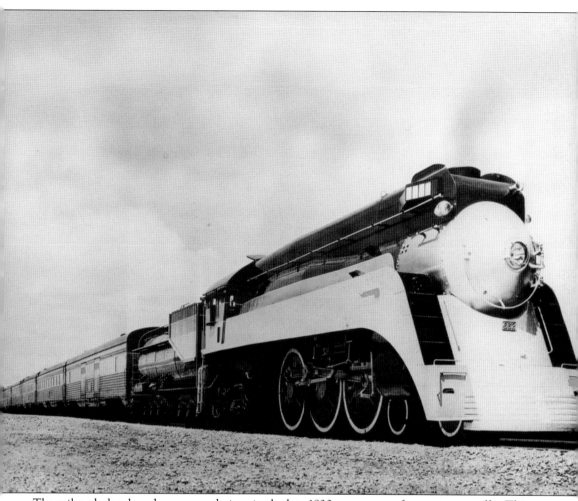

The railroads developed numerous designs in the late 1930s to compete for passenger traffic. This Southern Pacific model, the *Sunbeam*, dates to around this time and is a 4-6-2 steam locomotive that traveled between Dallas and Houston. The distance of 265 miles was covered in 265 minutes in 1937. The design of the new streamliners gave an impressive new appearance to these passenger trains well into the 1940s. (Courtesy of Museum of the American Railroad.)

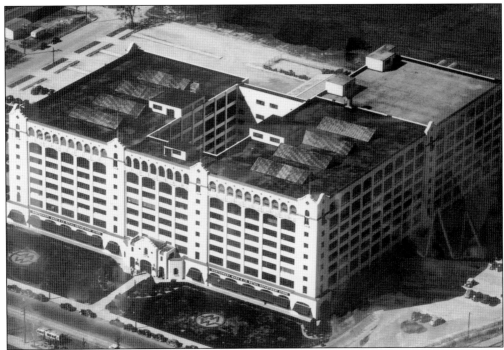

In 1928, Montgomery Ward built a massive 300,000-square-foot building on West Seventh Street. Though this was built only a few years before the Great Depression would hit the Fort Worth economy, an additional 230,000 feet were added in 1937. As it was a premier retailer of the day, having Montgomery Ward place such an enormous building in Fort Worth was a testament to the city's bright prospects at the end of the 1920s. (Courtesy of Tarrant County College District Archives.)

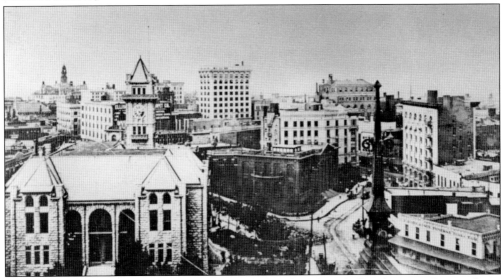

This aerial view of downtown Fort Worth in 1930 from Ninth and Throckmorton Streets shows Fort Worth at the end of the booming prosperity of the 1920s. The city had enjoyed a massive demographic boom and developed modern infrastructure systems for electricity, communications, and transportation. (Courtesy of Tarrant County College District Archives.)

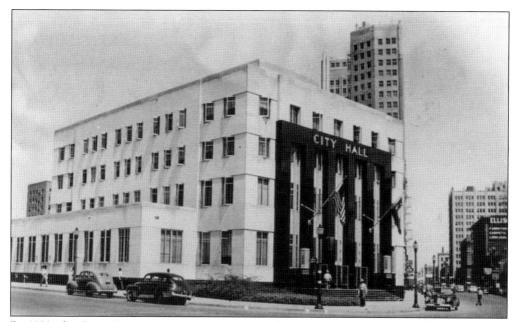

By 1932, the Great Depression was causing as much misery in Fort Worth as elsewhere in the country, and the city sought federal assistance. Under the New Deal, funds were provided for approved public projects, and federal spending reached nearly $15 million in the 1930s. The construction of a new Fort Worth City Hall, seen above, occurred at this time. (Courtesy of Tarrant County College District Archives.)

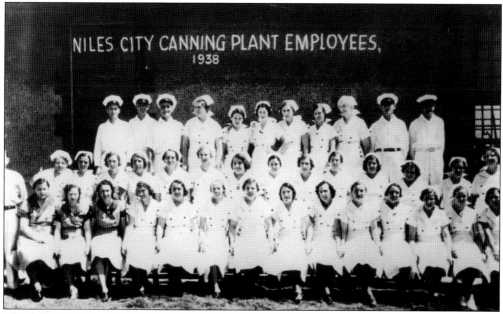

The different New Deal agencies worked on a wide variety of civic projects around the country. The photograph above features the employees for the Niles City Canning Plant, about three miles north of downtown Fort Worth. The plant was constructed as part of a Works Progress Administration (WPA) project under President Roosevelt's New Deal programs. (Courtesy of Tarrant County College District Archives.)

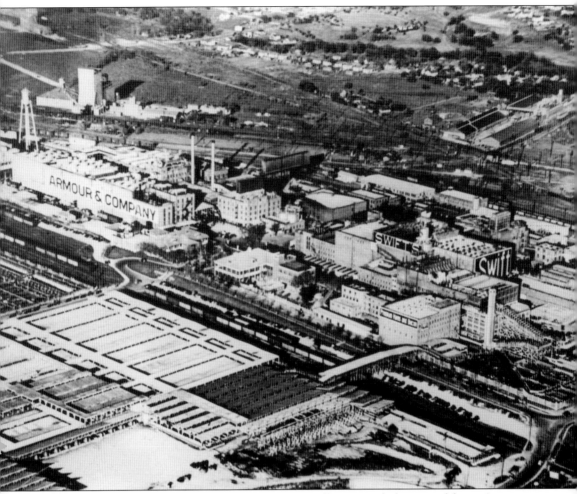

The Fort Worth Stockyards and meatpacking plants still comprised a big part of the city's economic health. Even in the 1930s, with the oil boom and the beginnings of the aviation industry that was to mature in later years, the cattle industry was obviously present in the massive grounds it occupied in the city; the industry still gave credence to Fort Worth's nickname "Cowtown." (Courtesy of Tarrant County College District Archives.)

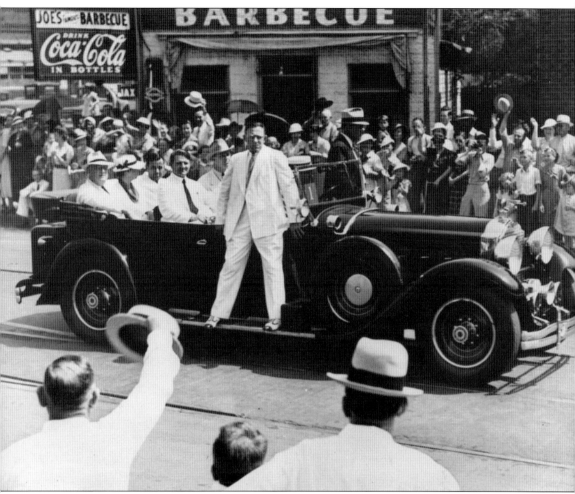

As in the rest of the country, the 1930s were a bitter decade compared with the prosperity of the 1920s. By 1936, President Roosevelt's New Deal program was in full swing, and he would make five visits to Fort Worth, the first being in an open car. He would come back for a notable visit by train in 1938 and give a radio address to the nation. His son Elliott lived nearby in Benbrook at the time and operated a radio station in Fort Worth. In this photograph, Roosevelt is in Dallas. He would later come to Fort Worth but not before being drenched by rain in the open car. (Courtesy of Dallas Firefighters Museum.)

Passenger travel continued throughout the 1930s, and there was no certainty that the yet emerging aviation and automobile technologies would replace trains in the future. This 900 class Texas & Pacific *Sunshine Special* train is parked in downtown Fort Worth outside the railroad depot with the T&P station behind it. (Courtesy of Tarrant County College District Archives.)

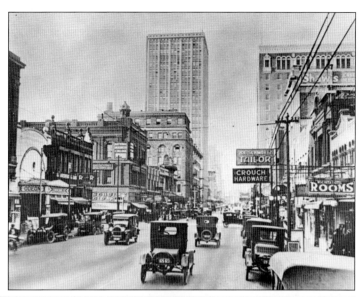

Automobiles steadily made their way into the street scene throughout the 1920s. The interurban railroad was quickly becoming overshadowed. In this photograph from 1930, the intersection at Main and Eighth Streets is lined with cars. Traffic regulations had to be established to manage the vast amount of cars pouring into the downtown area. (Courtesy of Tarrant County College District Archives.)

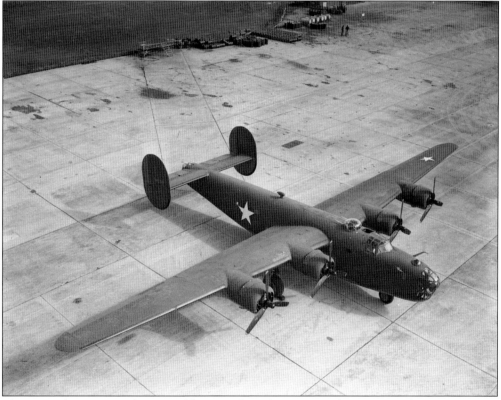

The B-24 Liberator, seen here, would emerge from the Fort Worth aviation industry as a crucial instrument in winning World War II. The relatively meager aviation industry that had its development impeded by the Great Depression emerged during the war years as a massive weapon of war and transportation. In yet another transformation, Fort Worth's newest economic pillar would be the aviation industry in the war and postwar years. (Courtesy of Lockheed Martin Aeronautics Company.)

The Pacific-type 4-6-2 locomotives were increasingly used in the 1920s as more railroads adopted them for their passenger services. In this 1926 image, the Southern Pacific's *Sunset Limited* is westbound in Texas to California. (Courtesy of Museum of the American Railroad.)

The railroads could offer a tiered structure of travel for passengers. Speedier services like the *Sunset Limited* were oriented to first-class customers, while more economical services like the Southern Pacific's *Argonaut* delivered passengers from Los Angeles to New Orleans several hours later than the *Sunset Limited*. In this image, two *Argonaut* passenger trains pass one another in West Texas in 1929. (Courtesy of Museum of the American Railroad.)

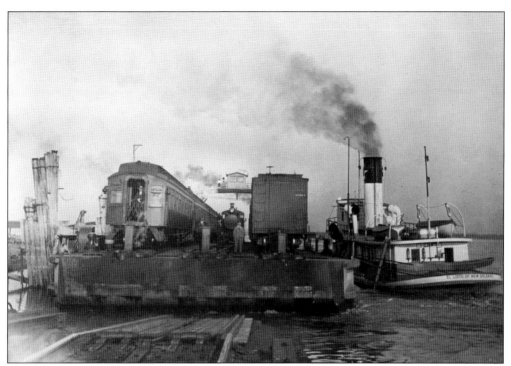

Transiting trains over waterways was a delicate operation of ferrying the train cars from one side of a river to the next. In this image, the Southern Pacific's *Mastodon*, a barge operated by the railroad, is pulled by tugboats and carries a passenger train over the Mississippi River in New Orleans. (Courtesy of Museum of the American Railroad.)

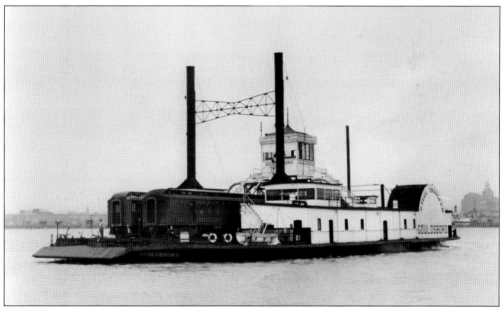

Besides barges, steam ferryboats could carry passenger cars across large waterways. The Texas & Pacific's *Gouldsboro* ferries two passenger cars across the Mississippi River in New Orleans in 1938. (Courtesy of Museum of the American Railroad.)

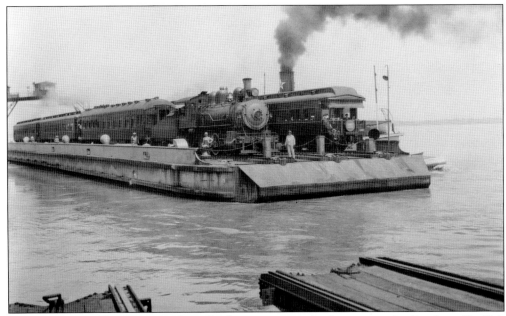

Barges were capable of carrying large loads across rivers. In this image, the Southern Pacific's *Sunset Limited* crosses the Mississippi River using the same *Mastodon* barge in 1930 as it probably moves between the railroad's yards at Algiers and Elysian Fields. (Courtesy of Tarrant County College District Archives.)

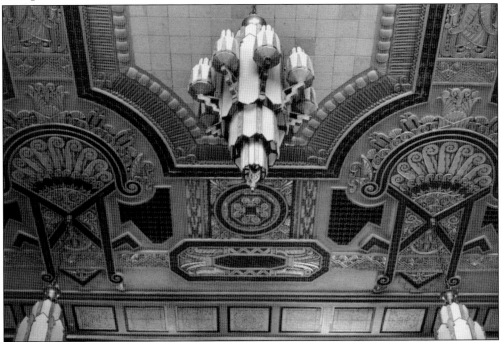

The ornate interior Art Deco architecture of the Texas & Pacific station was as remarkable, if not more so, as the exterior design of the building. The colorful symmetry and designs even around the light fixtures, as seen in this photograph, could be an awe-inspiring sight to passengers waiting around inside the station. (Courtesy of Tarrant County College District Archives.)

Four
BEYOND CATTLE

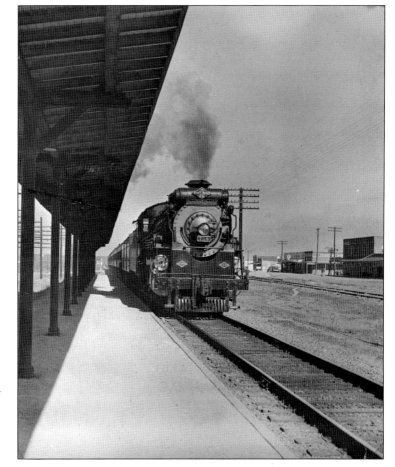

Here, the T&P's *Sunshine Special* rolls into Fort Worth in 1940. These were overnight, business-oriented trains that were scheduled to arrive in the Dallas–Fort Worth area at about 9:00 a.m. The coming war years were to see major changes in the nation's economy and the spectacular growth of the aviation industry in Fort Worth. (Courtesy of Boyce Ditto Public Library.)

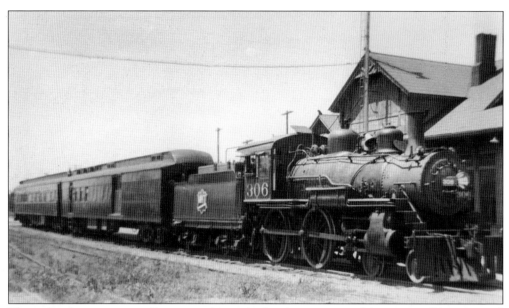

The railroad system was well integrated into the local economies of the surrounding cities and towns in the North Texas area. Whereas in the earlier decades, major connections were made between important junctures across the nation and in the metropolitan areas, by 1940, the railroads were vital connections to communities a distance away from major cities like Dallas and Fort Worth. In this photograph is a 4-4-0 locomotive operated by the Katy Railroad in Gainesville, Texas, in 1940. (Courtesy of Museum of the American Railroad.)

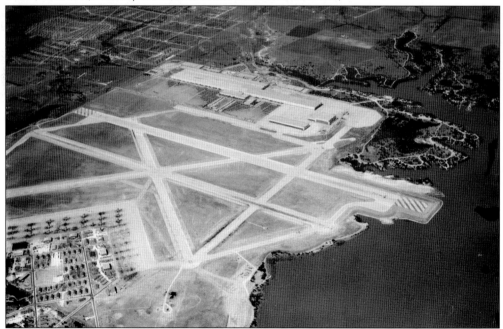

The Fort Worth City Council bought and put aside 526 acres in September 1941 for the US Army to build a bomber plant. Tarrant Field was built alongside the plant for pilots to fly the airplanes. The bomber plant was to mark the next transition in the Fort Worth economy as aviation became a major industry in town. (Courtesy of Lockheed Martin Aeronautics Company.)

The city of Fort Worth was a major contributor to the Allied victory in World War II. Here, the man with the white hat and the cane is Britain's ambassador, Lord Halifax; he was present when the first B-24 came out from production. The city that had begun with railways was now a leader in the American war effort. (Courtesy of Lockheed Martin Aeronautics Company.)

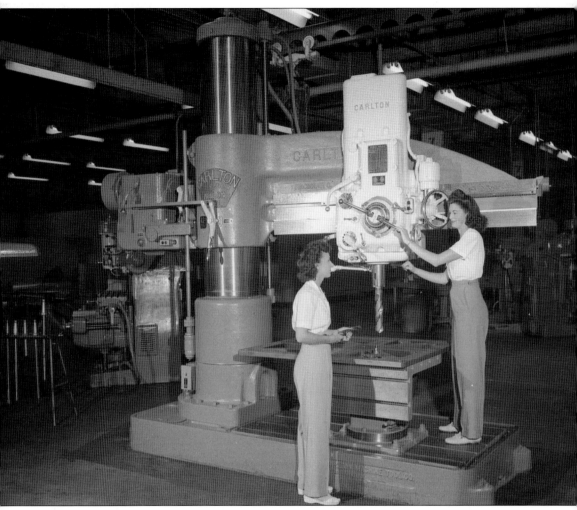

The war effort massively expanded the manufacturing sector in Fort Worth. Between 1920 and 1940, this sector had tripled, but during the war, nearly 100 businesses had been added. The high demand for labor would bring new workers to the city and bring many women into the workforce while so many men were being sent overseas. Here, two women work on a drill press at the Consolidated Vultee Aircraft Corporation in 1945. (Courtesy of Lockheed Martin Aeronautics Company.)

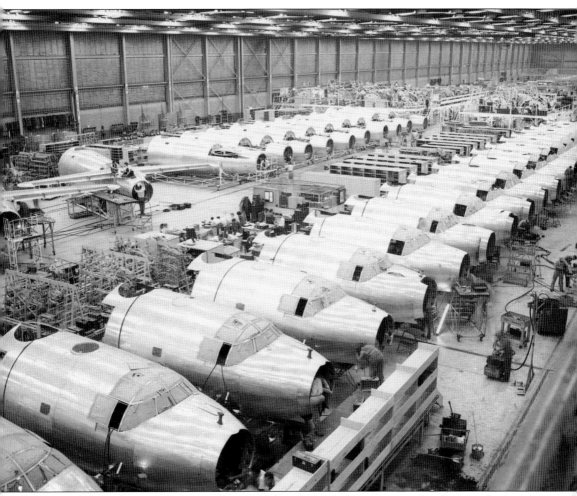

By the close of the war, the Consolidated Vultee Aircraft Corporation plant was producing a new bomber, the B-32 Dominator. This photograph of the tail and nose lines provides a glimpse of the scale of aviation manufacturing this plant was able to produce. In the span of a few years, the city of Fort Worth had become an international manufacturing hub for aviation. (Courtesy of Lockheed Martin Aeronautics Company.)

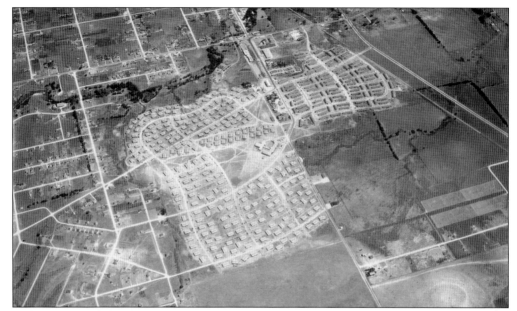

Fort Worth's population expanded from 177,662 in 1940 to 278,778 in 1950. This photograph of Liberator Village, which was constructed as government housing for the bomber production effort, was indicative of this demographic shift. The city had a healthy economy based on oil, livestock, crops, railroads, and the booming aviation sector. (Courtesy of Lockheed Martin Aeronautics Company.)

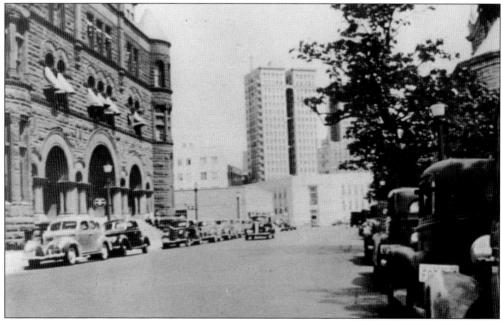

This photograph shows downtown Fort Worth as seen from Jennings Street in 1942. Many of the wartime changes had not yet taken hold in the city at this point during the war. However, urban transportation was dominated by cars lining the streets on both sides. The following years would see steady changes in traffic as Americans increasingly moved toward relying on automobile transportation. (Courtesy of Tarrant County College District Archives.)

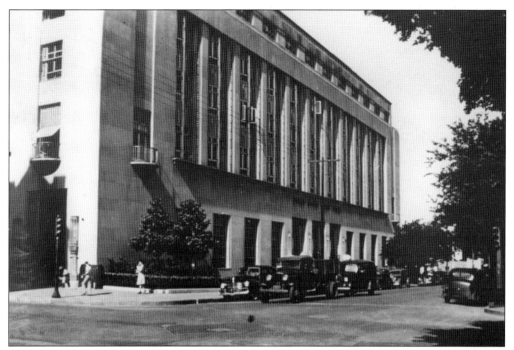

As the population grew in the interwar and war years, improvements in downtown Fort Worth continued to sprout up. This federal courthouse was built in 1940 and was a marker of the presence of the federal government in the area. (Courtesy of Tarrant County College District Archives.)

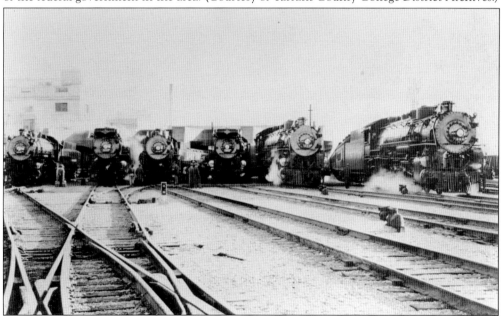

Rail was still preferable for transportation when it came to long distances. Partly owing to the lack of a national infrastructure for automobiles and to the ease of passenger rail, railroads were still central to people's lives when it came to travel. Here in 1936, Rose Bowl fans depart Dallas heading to Pasadena, California, on six special Texas & Pacific trains headed by a 900 class Mountain-type 4-8-2 locomotive. (Courtesy of Museum of the American Railroad.)

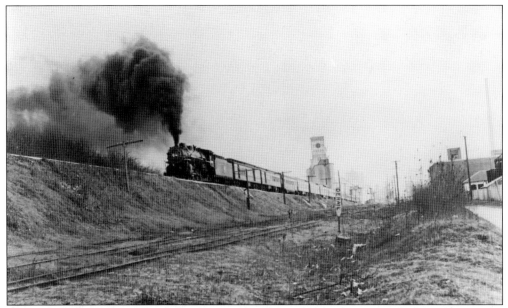

During the 1940s, the steam locomotives were still the mainstay of the railroads. In this photograph, the Katy *Texas Special* is moving northward from Dallas in a Pacific 4-6-2 locomotive in 1946. (Courtesy of Museum of the American Railroad.)

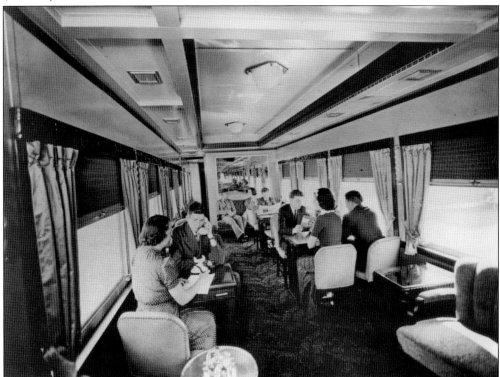

Travel by railroad had the added convenience of luxury. Here is the lounge car on the Katy's *Bluebonnet* on passage from Dallas to San Antonio. This shows what a standard lounge looked like in 1943. (Courtesy of Museum of the American Railroad.)

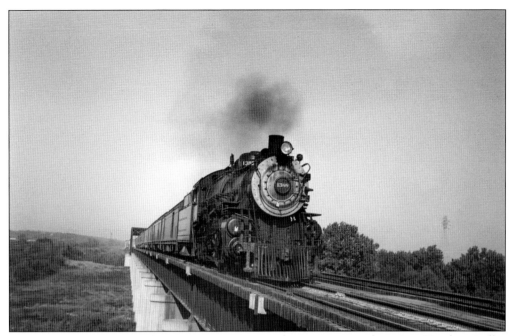

Here, the Santa Fe Railroad's *Kansas Cityan* crosses the Trinity River from Fort Worth to Dallas in 1948. Even just prior to the war, new services were established as the railroads still vied with one another for customers. This train is a Pacific-type 4-6-2 locomotive. (Courtesy of Museum of the American Railroad.)

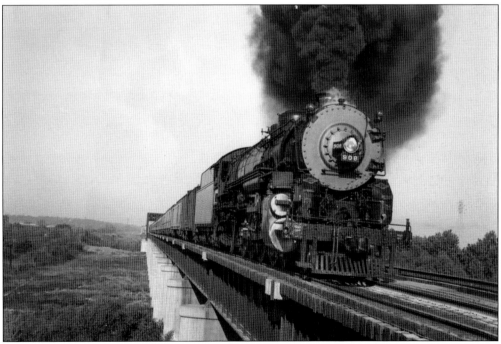

The Texas & Pacific was still a major railroad in the 1940s. Here, the T&P's *Southerner* crosses the Trinity eastbound toward Dallas from Fort Worth in 1948. The train is a 900 class Mountain-type 4-8-2 locomotive. (Courtesy of Museum of the American Railroad.)

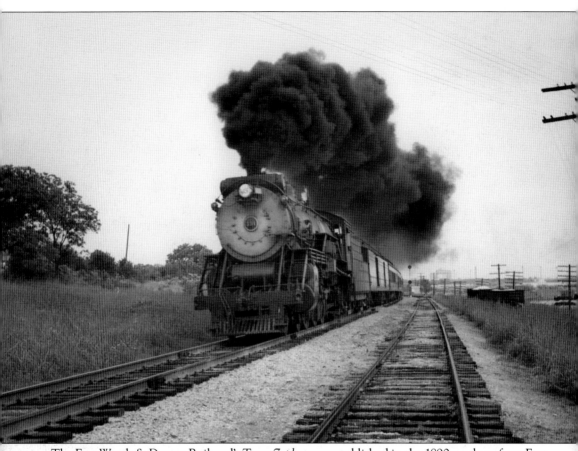

The Fort Worth & Denver Railroad's *Texas Zephyr* was established in the 1890s and ran from Fort Worth to Denver, Colorado. This Pacific-type 4-6-2 locomotive is departing from Dallas in 1948. The Colorado & Southern Railway also operated the *Zephyr*; both railroads were subsidiaries of the Chicago, Burlington & Quincy Railroad. (Courtesy of Museum of the American Railroad.)

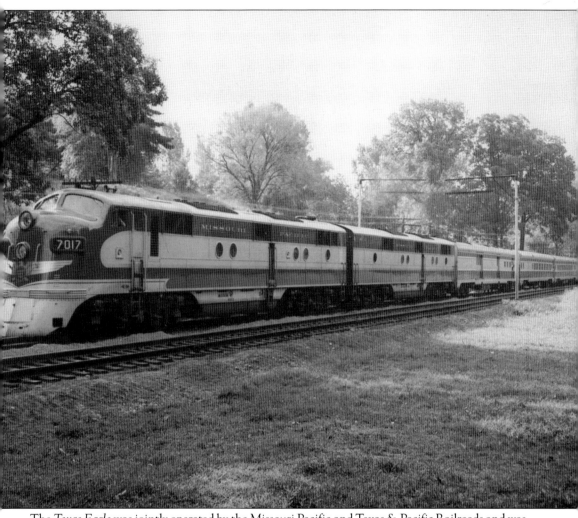

The *Texas Eagle* was jointly operated by the Missouri Pacific and Texas & Pacific Railroads and was a successor to the *Sunshine Special* service. In this 1948 photograph, the train is departing from St. Louis and is heading south toward its destinations in Texas. The *Texas Eagle* currently operated by Amtrak is a successor to this service. (Courtesy of Museum of the American Railroad.)

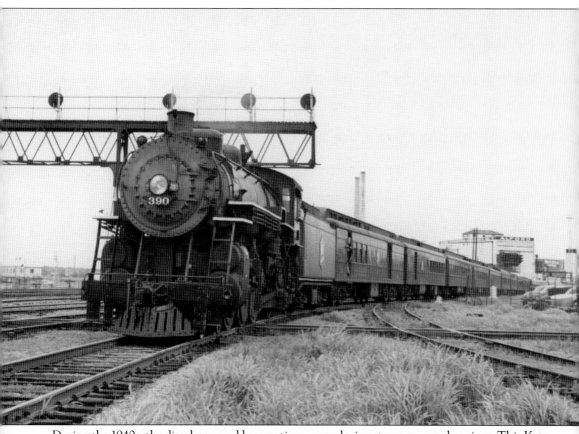

During the 1940s, the diesel-powered locomotive was replacing steam-powered engines. This Katy *Texas Special*, arriving in Dallas in 1948, is an example of a 4-6-2 locomotive immediately prior to the replacement by diesel power. The Great Depression had set back the advent of the diesel locomotive era, but from 1939 onwards, the diesel locomotives steadily began to replace steam locomotives. (Courtesy of Museum of the American Railroad.)

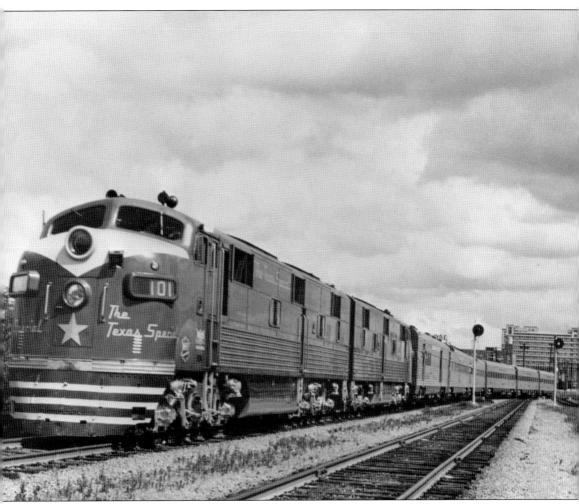

The diesel-powered locomotive seen here is the northbound Katy Railroad *Texas Special* arriving in Dallas in April 1948. Diesel locomotives had several operational advantages over steam engines. Though they were more costly than the steam locomotives they replaced, they were cleaner and quieter than their counterparts. In addition, they only needed one operator. (Courtesy of Museum of the American Railroad.)

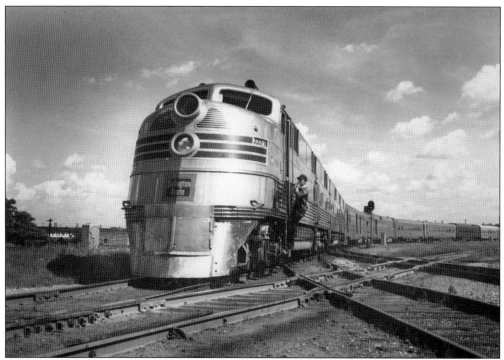

By 1950, diesel locomotives were becoming common, even though it would still take until the 1960s before steam locomotives were completely replaced by diesel locomotives. In this photograph, the Fort Worth & Denver Railroad's *Texas Zephyr* is in Fort Worth in 1950. (Courtesy of Museum of the American Railroad.)

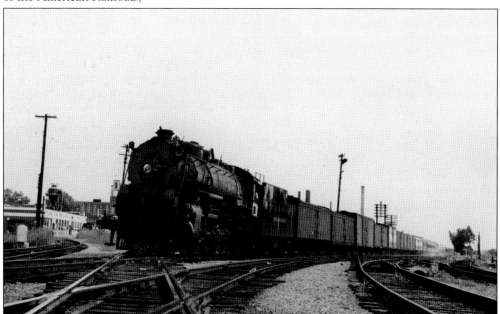

This photograph shows a Texas & Pacific Railroad 4-8-2 locomotive carrying a mail and express service into Dallas in 1950 as it heads to El Paso. The locomotives were still used for a variety of purposes. (Courtesy of Museum of the American Railroad.)

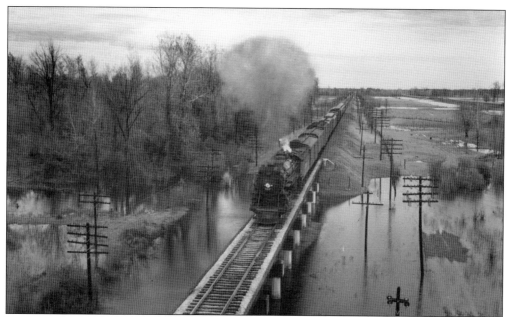

Traveling by train allowed passengers incredible experiences. The luxury and scenery provided by train travel still lingered in American minds in the postwar period even when travel by automobile became increasingly prevalent. The Missouri Pacific's *Westerner* is moving westward through Fulton, Arkansas, over the Red River to its destination in El Paso in a Mountain-type 4-8-2 locomotive. (Courtesy of Museum of the American Railroad.)

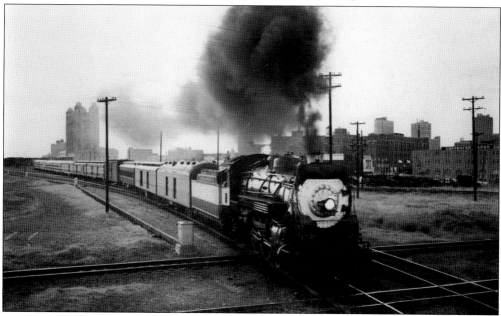

The Texas & Pacific Railroad was still a major corporation in Fort Worth in the 1940s but was less prominent. Nevertheless, the railroad had survived the Great Depression and had seen an expansion of freight traffic with wartime demands for West Texan oil, foodstuffs, and production. In this photograph, a steam Pacific-type 4-6-2 locomotive leads the *Louisiana Limited* service on a summer afternoon in 1950. (Courtesy of Museum of the American Railroad.)

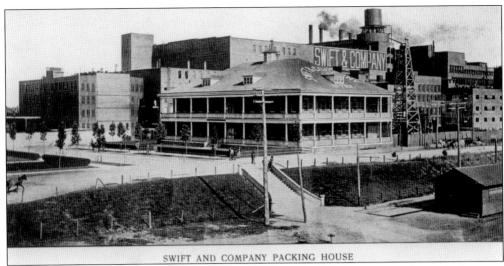

SWIFT AND COMPANY PACKING HOUSE

Fort Worth in the 1940s still showed its Cowtown roots, and the wartime demands for meat meant that Armour and Swift's business was at its peak. The livestock market was the largest south of Kansas City, and by 1952, the Armour and Swift plant had been in Fort Worth for 50 years, during most of which it was the most important industry in the city. (Courtesy of Tarrant County College District Archives.)

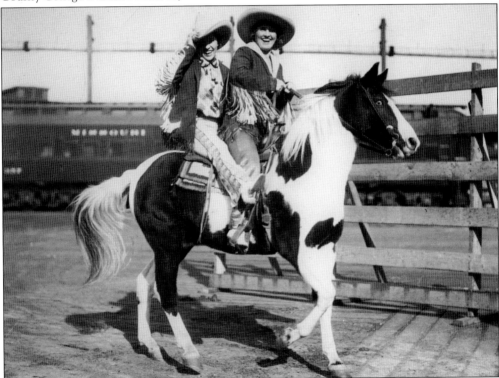

Even at mid-century and with all the changes that had happened in the city in the preceding decades, Fort Worth was a city that still treasured its frontier heritage. In this photograph, Ruth Roach (right) and Tad Lucas ride on a horse at a train yard in Fort Worth in February 1949. (Courtesy of University of North Texas Archives.)

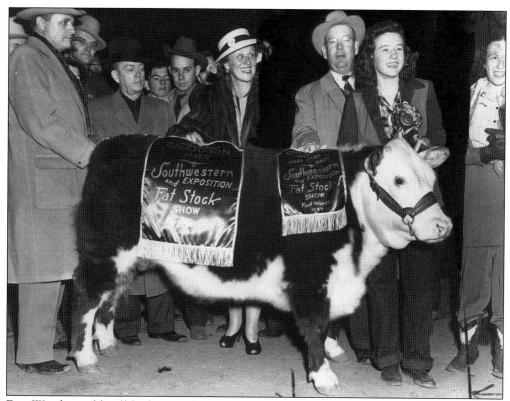

Fort Worth would still be known for its first industry, cattle raising. As time went on, other industries would eclipse it, but as can be seen in this 1947 photograph of the winner of the Fort Worth Fat Stock Show, the city still proved worthy to be called Cowtown. It was this industry that first attracted the attention of the railroads and laid the groundwork for the succeeding industries. (Courtesy of Cattle Raisers Museum.)

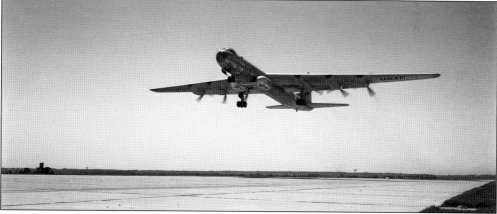

After World War II ended, the city worried about the slowdown in the war effort, causing the labor that had come to Fort Worth during the war years to leave for economic opportunities elsewhere. However, the B-36 Peacemaker, seen taking off in this photograph in April 1950, proved to be a vital aircraft needed for the postwar national defense industry. This nuclear bomber would be the primary aircraft for the new Strategic Air Command (SAC) in the first years of the Cold War. (Courtesy of Lockheed Martin Aeronautics Company.)

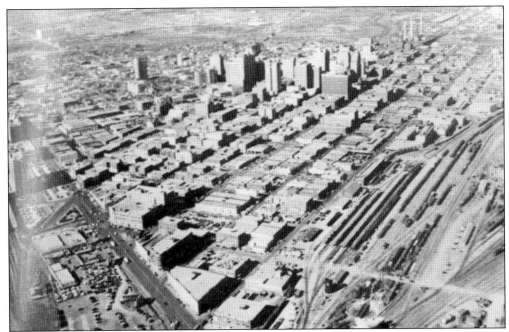

By 1950, at the time this aerial photograph was taken, Fort Worth was a large, metropolitan American city. It had a diversified economy and was a leader in the aviation industry. The city had emerged from the doldrums of the Great Depression and through World War II standing in many respects an equal to its formidable sister city, Dallas. Most of the credit for all this prosperity was due to the role played by the railroads that gave the city its centrality as a transportation hub in the Southwest. (Courtesy of Tarrant County College District Archives.)

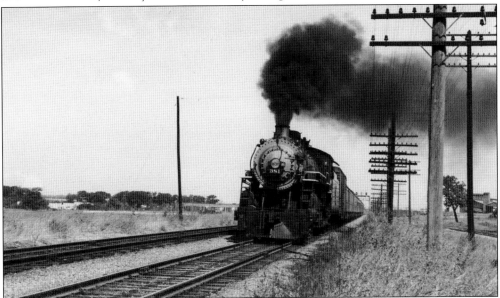

The Katy Railroad struggled during the Depression and came close to bankruptcy before World War II provided a boon for business. In 1944, the railroad had a $6-million profit, but management conflicts arose during the postwar years. Hear, a Katy 4-6-2 locomotive is near Dallas in 1948. (Courtesy of Museum of the American Railroad.)

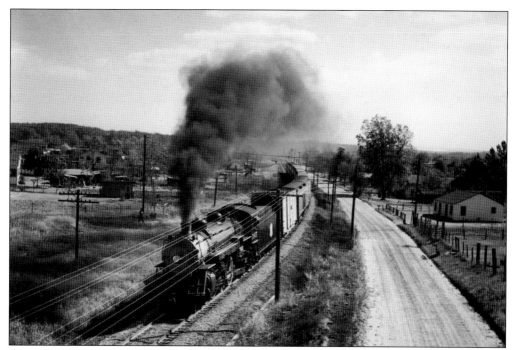

The oldest service of the Katy Railroad was the *Katy Flyer*, which opened in 1896 and operated between Galveston, Texas, and St. Louis. In this image, a Katy 4-6-2 is shown departing from Denison northbound to St. Louis in 1949. (Courtesy of Museum of the American Railroad.)

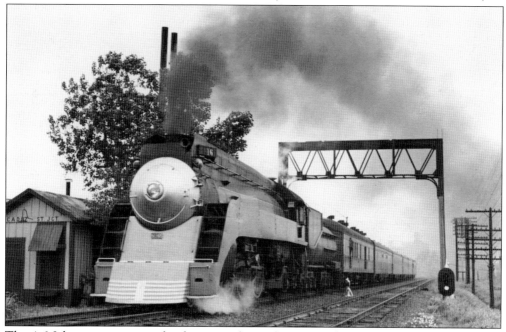

The 4-6-2 locomotives were the dominant form of passenger locomotives between the 1920s and 1940s. The trains were too light to carry heavier loads and were optimized for speed so that passengers could be delivered on time. In this 1948 image, a 4-6-2 operated by the Southern Pacific Railroad departs from Dallas. (Courtesy of Museum of the American Railroad.)

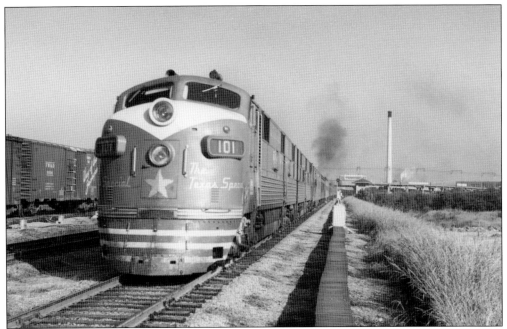

The *Texas Special* was upgraded in 1947 from a steam to a diesel locomotive, reflecting the general trend away from steam in the late 1940s. In this image, the *Texas Special* departs Dallas and begins heading toward San Antonio via Fort Worth in 1949. (Courtesy of Museum of the American Railroad.)

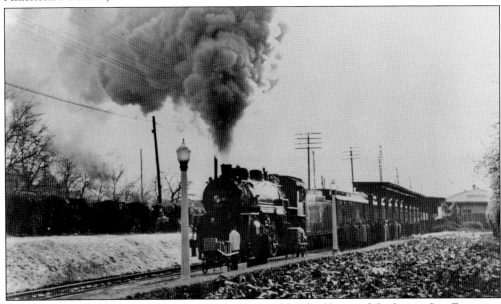

The *Texas Special* service, which was jointly managed by the Katy and St. Louis–San Francisco (Frisco), ran between San Francisco, California, and St. Louis, Missouri, via a southern route through Texas. Different locomotives pulled the service during the 1940s due to the heavyweight passenger cars. Depending on the segment of the service it was on, the locomotive could be a Katy Pacific-type 4-6-2 or a Frisco 4-8-2 or 4-8-4. In this photograph, the *Texas Special* is arriving at the Highland Park depot in Dallas in December 1940. (Courtesy of Museum of the American Railroad.)

Five

MERGING INTO THE "METROPLEX"

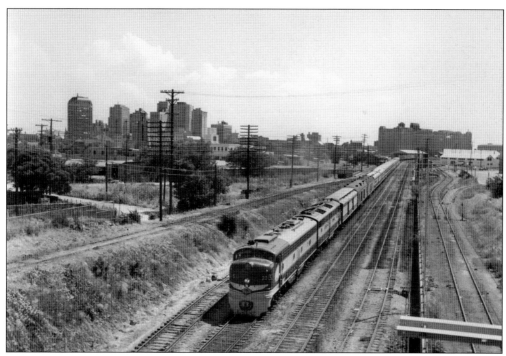

During the 1950s, aviation and automobiles gradually replaced the central role that the railroads had played in people's lives as a form of transportation and a part of urban culture. Yet Americans still used the railroad in large numbers and revered the railroad in the nation's history. In this photograph, the *Texas Eagle* departs Fort Worth for El Paso on June 28, 1953. (Courtesy of Museum of the American Railroad.)

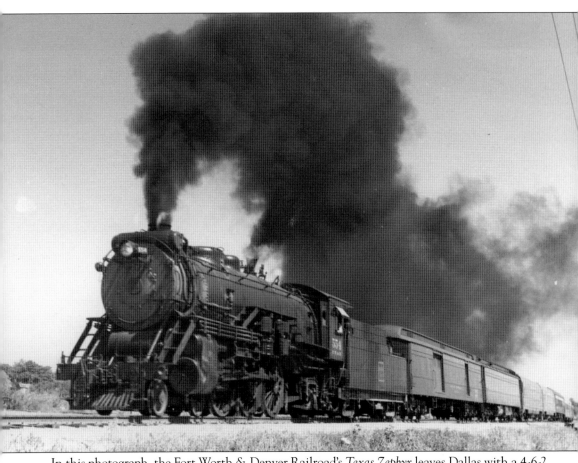
In this photograph, the Fort Worth & Denver Railroad's *Texas Zephyr* leaves Dallas with a 4-6-2 locomotive on September 13, 1954. The Fort Worth & Denver Railroad gradually replaced its 4-6-2 locomotives in the postwar years with E5 diesel locomotives but kept a 4-6-2 running between Dallas and Fort Worth due to the short period of maintenance needed for steam locomotives compared with their diesel replacements. (Courtesy of Museum of the American Railroad.)

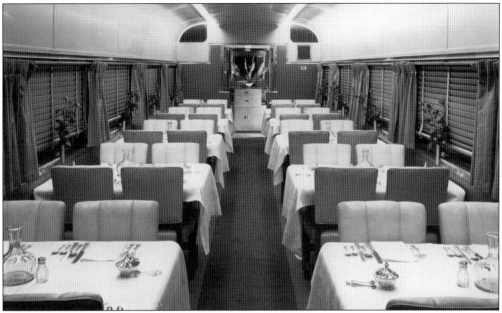

This 1953 photograph displays the Fort Worth & Denver *Texas Zephyr* passenger dining car, a particularly necessary car for a 17-hour service between Dallas and Denver. A typical menu featured a pretty wide array of options for passengers, including creamed chicken soup, a lettuce and tomato salad, a chicken salad sandwich, fish filets, a Spanish omelet, and a choice of dessert between a sherbet and fruit cobbler. (Courtesy of Museum of the American Railroad.)

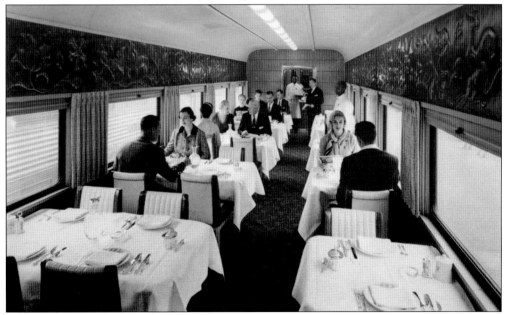

In this photograph, diners enjoy a dinner in 1956 on board the Santa Fe's *Texas Chief* line, southbound from Chicago to Dallas–Fort Worth. Though Americans were increasingly choosing automobiles for travel over the railroads, the railroads had no rival for luxury. The professional diner staff took orders from passengers and passed them on to the kitchen. (Courtesy of Museum of the American Railroad.)

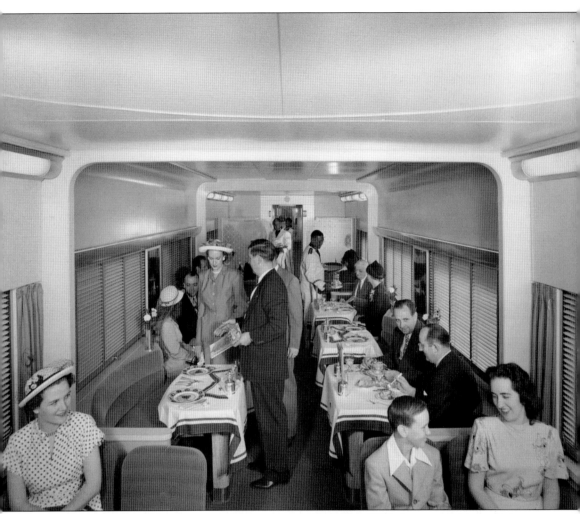

Different designs of dining cars could vary a great deal. This 1959 photograph is of a dining car on the Missouri Pacific's *Texas Eagle* service, which ran between St. Louis and Texas. Though many dining car designs featured tables with chairs situated around them, this unique design had diners seated at the sides of the car with the tables near the middle. (Courtesy of Museum of the American Railroad.)

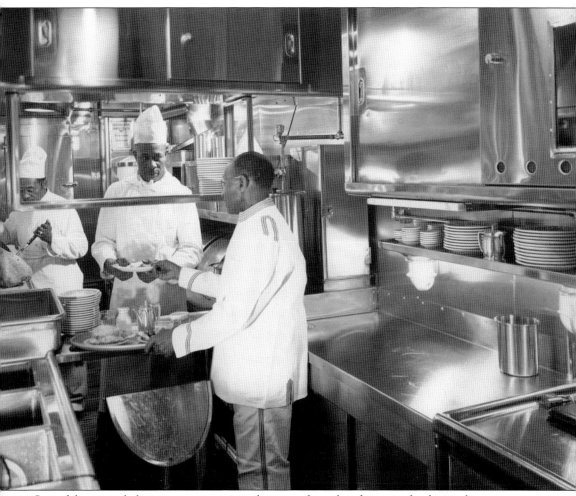

One of the grounds for intense competition between the railroads was in the dining departments. In this photograph of the *Southern Belle*, a passenger service run by the Kansas City Southern Railway that ran between Kansas City and Shreveport, Louisiana, the chefs and assistants prepare dinner in a fully equipped kitchen in 1959. The design and staffing of the kitchen in the dining car made possible a variety of menu options for passengers. (Courtesy of Museum of the American Railroad.)

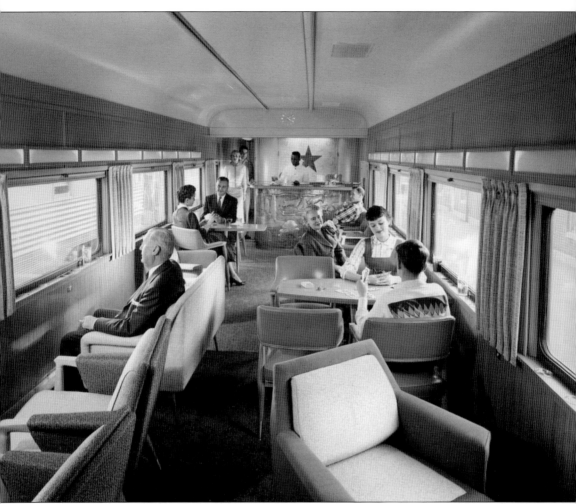

The transcontinental railroads kept up with the changes that were going on concurrently in American fashion trends. In this 1956 photograph of the lounge car of the Santa Fe's southbound *Texas Chief*, passengers relax in modern, sleek furniture with fashion patterns popular in the mid-1950s. (Courtesy of Museum of the American Railroad.)

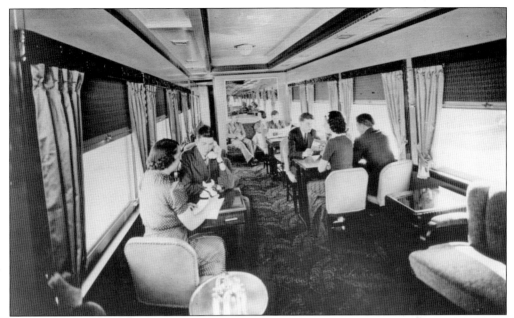

In addition to dining cars, passenger lines had lounge cars for passengers to relax and purchase food and drinks. In this 1943 photograph, this parlor lounge car on the Katy's *Bluebonnet* train is southbound from Dallas to San Antonio. Lounge cars were an alternative to the more formal dining cars, and passengers were able to enter these cars more at their own leisure. (Courtesy of Museum of the American Railroad.)

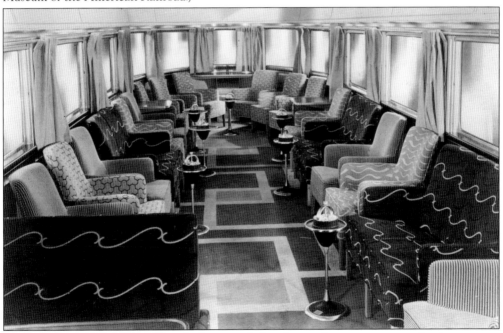

The observation car of the *Texas Zephyr* provided a chance for passengers to relax in a serene, social atmosphere. The cars were placed at the back of the train to allow the best chances to observe the landscape around the tracks. These cars were largely removed in the 1950s as an efficiency measure. (Courtesy of Museum of the American Railroad.)

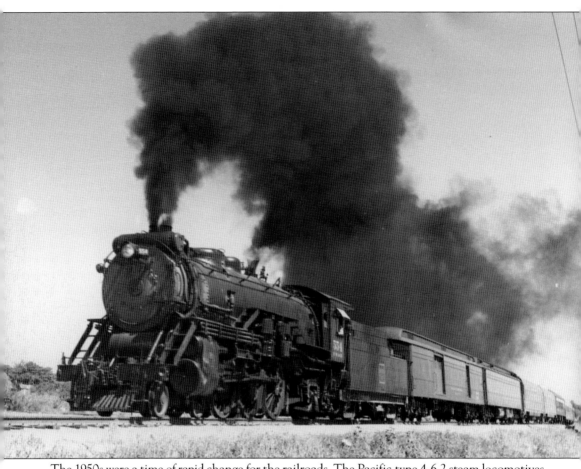

The 1950s were a time of rapid change for the railroads. The Pacific-type 4-6-2 steam locomotives, as in this September 1954 photograph of a *Texas Zephyr* heading toward Dallas, were still being used up to the late 1950s despite being the dominant locomotive for five decades. However, diesel engines finally overtook them in this crucial decade for the railroads. (Courtesy of Museum of the American Railroad.)

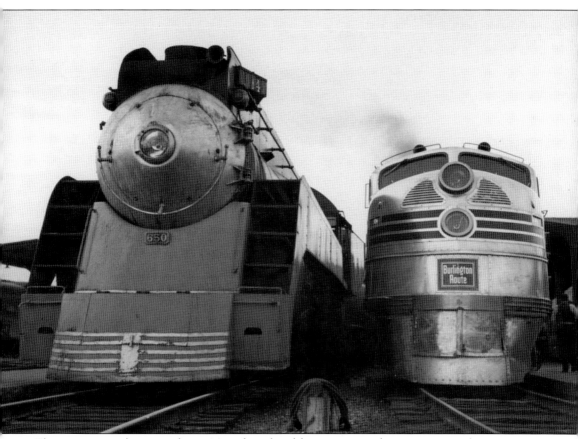

The comparison between the 4-6-2 and its diesel locomotive replacement was a sharp one to many eyes. In this photograph, the Southern Pacific's *Sunbeam*, which ran between Dallas and Houston, stands next to the Burlington's *Sam Houston Zephyr* at the Dallas Union terminal in 1950. (Courtesy of Museum of the American Railroad.)

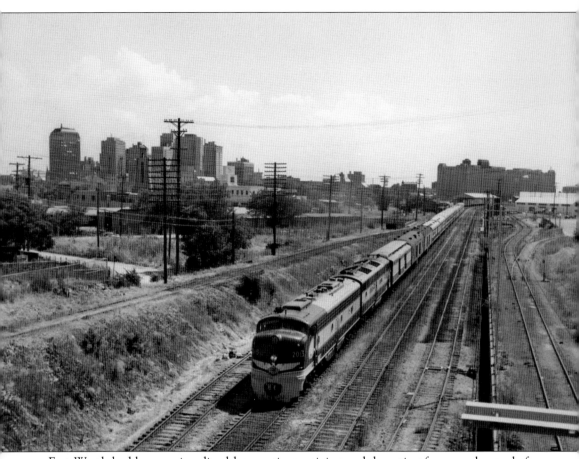

Fort Worth had been seeing diesel locomotives arriving and departing for several years before the great changes in locomotive technology took a large effect in the early 1950s. The Texas & Pacific's *Texas Eagle* with its diesel locomotive departs Fort Worth for El Paso on June 28, 1953, in this photograph. (Courtesy of Museum of the American Railroad.)

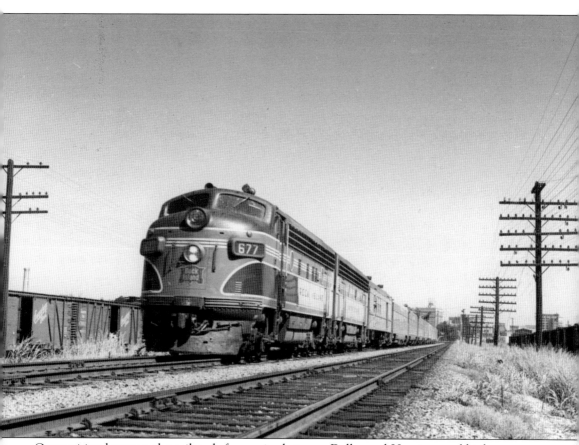

Competition between the railroads for service between Dallas and Houston could take a very sporty edge. In this 1951 photograph, the Burlington-Rock Island's *Twin Star Rocket* departs Dallas southbound to Houston in a race to arrive in Houston before the Southern Pacific's *Hustler*. At one point, the Texas & New Orleans Railroad's *Sunbeam*, Burlington-Rock Island's *Twin Star Rocket*, and Missouri Pacific's *Hustler* all were involved in races to get to their destinations the fastest. (Courtesy of Museum of the American Railroad.)

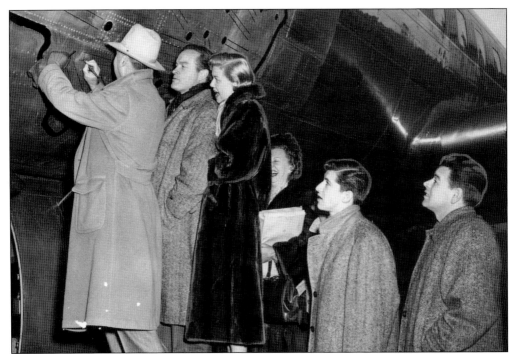

In Fort Worth, the aviation industry was drawing national attention long after the war was over. In this 1949 photograph, comedian Bob Hope autographs a jet airplane during a visit to Fort Worth. The city would garner even greater attention in the coming decades as the aviation industry continued to mature with technological advances being made. (Courtesy of University of Texas at Arlington Library.)

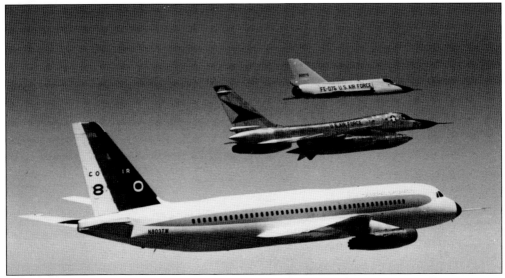

The Convair plant would generate many different models of airplanes for the stiff competition with the Soviet Union in the Cold War. In this October 1960 photograph, three types of Convair aircraft fly next to one another. The 880 in the front was a narrow-body passenger aircraft, the B-58 Hustler in the middle was the first operational supersonic jet bomber, and in the back is the F-106 Delta Dart interceptor. (Courtesy of Lockheed Martin Aeronautics Company.)

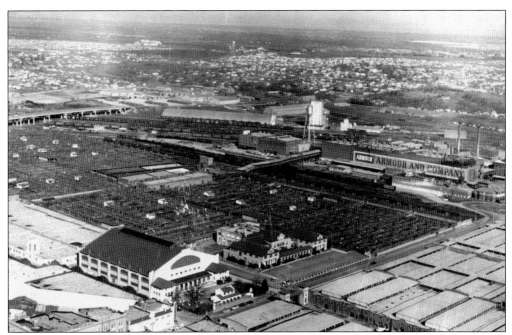

Cowtown still retained its value as the city's second major industry. However, beginning in 1951, the Armour and Swift meatpacking plant began making layoffs due in part to rising business costs and the organization of local cattle markets across the country. In this aerial photograph, the sign for the Armour and Swift plant hangs over the stockyards. (Courtesy of Cattle Raisers Museum.)

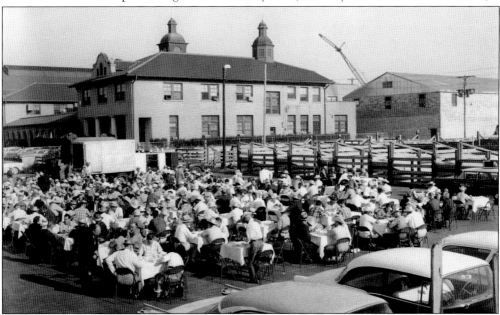

In this photograph, the 1960 Fort Worth Auction Market is opening. By this time, the stockyards had been in decline for a decade, and Fort Worth had even begun attracting cultural activities to prepare for the retraction. With the advent of the automobile naturally came the trucking industry, which allowed ranchers to send their cattle to other markets and auctions. (Courtesy of Cattle Raisers Museum.)

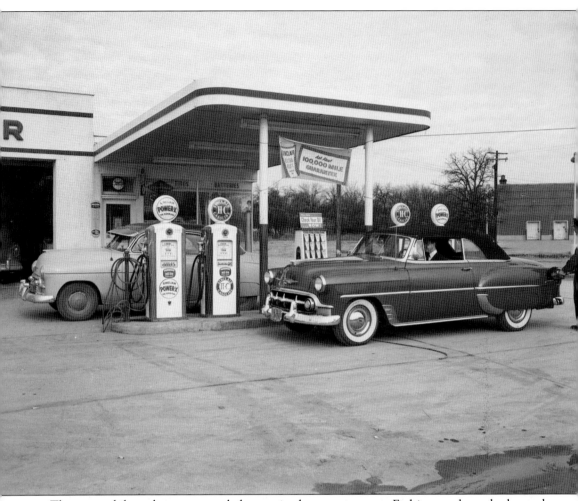

The automobile underwent several changes in the postwar years. Fashions and trends changed the industry as it increasingly competed for consumer tastes. By the 1950s, American cities were outfitted with the infrastructure of gas stations, traffic signs, meters, and lots to allow Americans to skirt a passenger train when they were traveling to other cities. In this photograph, a Sinclair gas station attendant fills up the tank of a motorist in 1954. (Courtesy of Lockheed Martin Aeronautics Company.)

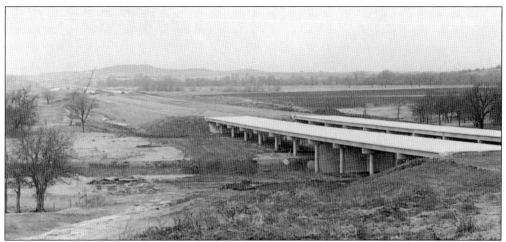

One of the major facilitators for long-distant travel was the nationwide system of highways constructed under the Federal Highway Act of 1956 that created the interstate highway system. Previously, motorists could traverse the nation, but the varying states of roads were uneven. Now, American motorists would have access to hardtop roads that allowed them to travel virtually anywhere in the nation via automobile. This photograph shows Interstate 35 West under construction between Denton and Fort Worth in 1959. (Courtesy of Lockheed Martin Aeronautics Company.)

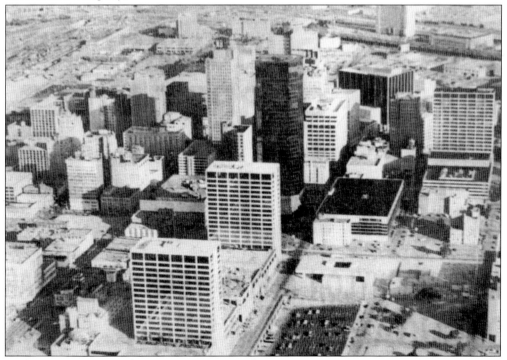

In the 1960s, Fort Worth was a major metropolitan city. During the 1950s and 1960s, the city gradually built a vibrant cultural foundation of museums, art institutes, convention centers, celebrations, and activities. Fort Worth had added nearly 400,000 citizens by 1970, the population spike after World War II largely due to the aviation industry. (Courtesy of Tarrant County College District Archives.)

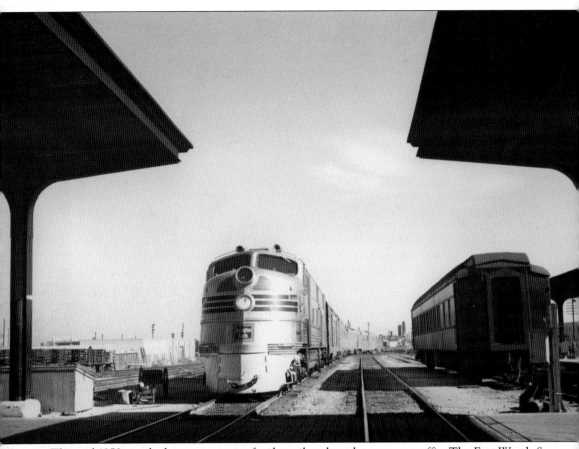

The mid-1950s marked a turning point for the railroads and passenger traffic. The Fort Worth & Denver Railroad's *Sam Houston Zephyr* arrives at the Texas & Pacific station in 1955. Changing railroad technology arrived on the scene at a time when the passenger traffic dropped to lower and lower levels. (Courtesy of Museum of the American Railroad.)

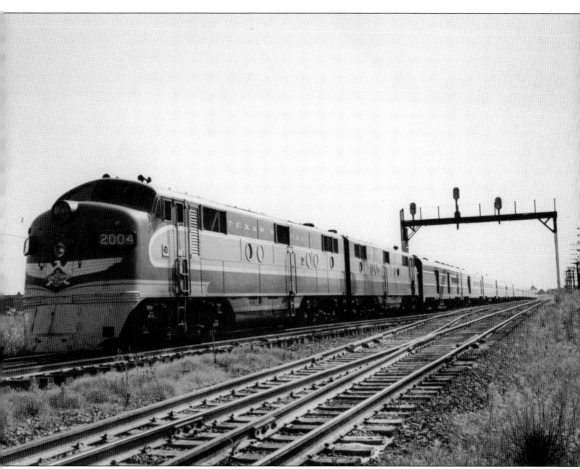

The Texas & Pacific Railroad began to encounter losses in the 1950s due to rising wages and declining passenger traffic. In this 1955 photograph, the *Texas Eagle* in Arlington is northbound to St. Louis. The company had not shown a profit from its passenger business line since 1946, and by the early 1960s, the company was recording millions in losses and attempting to cut its losses through efficiency measures. One official estimated in 1964 that 92 percent of travel was done by automobile. (Courtesy of Museum of the American Railroad.)

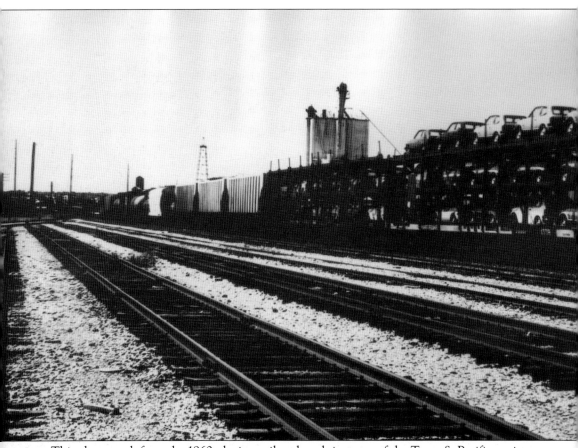

This photograph from the 1960s depicts railroad yards just east of the Texas & Pacific station on Vickery Boulevard and Interstate 35. The railroads had steadily lost much of their passenger and traditional freight traffic. This photograph shows a freight train carrying, among other things, a car full of automobiles. (Courtesy of Tarrant County College District Archives.)

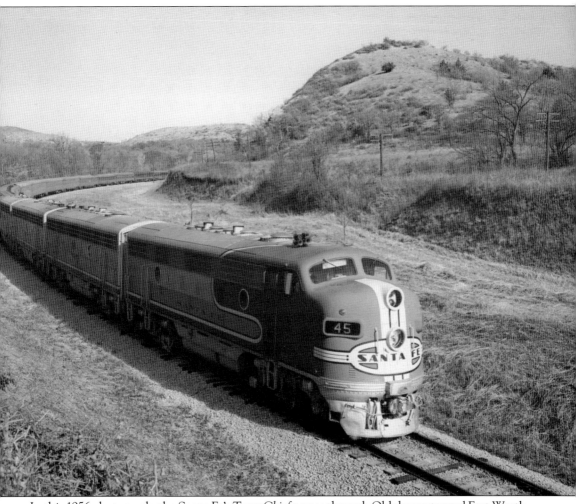
In this 1956 photograph, the Santa Fe's *Texas Chief* passes through Oklahoma toward Fort Worth with its 11 cars. During the late 1950s, the declining passenger markets left many railroads reliant on the railroad post offices, but even these were shut down in the 1960s, prompting the railroads to consider eliminating passenger traffic altogether except in a few areas of the country. Only the federal government intervened to ensure passenger rail service. When the federal government took control of the passenger rail lines in the 1970s, Amtrak picked up the *Texas Chief*. (Courtesy of Museum of the American Railroad.)

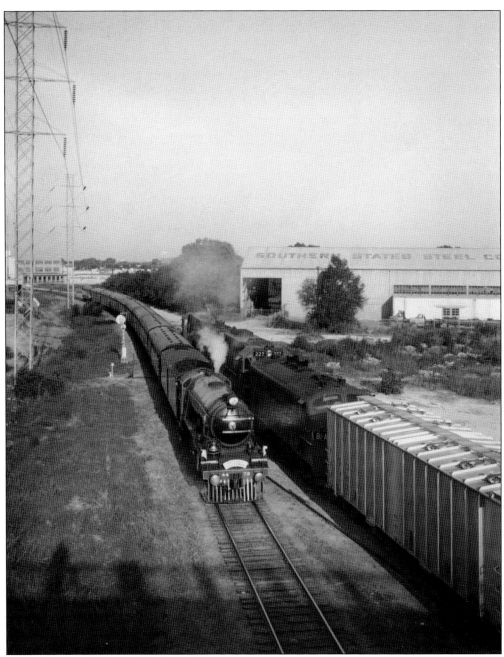

In this photograph, a legendary train, London & North Eastern Railway's *Flying Scotsman*, passes through the Dallas–Fort Worth area as it tours the United States in 1969. By the late 1960s, the railroads were operating a minimal level of passenger traffic. Yet nostalgia for the railroad was still active and vibrant in the public mind. Decorative and popular steamers like this one reminded Fort Worth citizens of the role the railroad had played in bringing people and markets to their city. (Courtesy of Museum of the American Railroad.)

This image shows Fort Worth's festive side as Consolidated Vultee Aircraft Corporation employees appear in a Fort Worth Fat Stock Show Parade in January 1951. The employees ride in the parade on horseback. New industries still live under the cattle ranching legacy that Fort Worth embraces even today. (Courtesy of Lockheed Martin Aeronautics Company.)

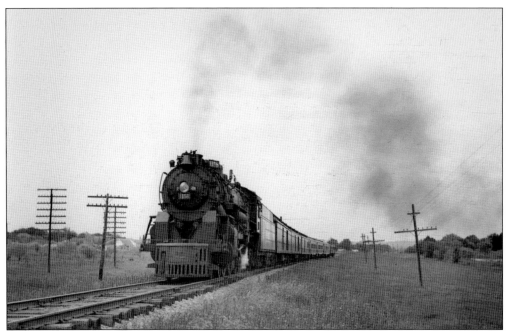

The Great Depression had adversely affected the Missouri Pacific Railroad. Having entered bankruptcy in 1933, the railroad was in receivership until 1956. Here, a Pacific-type 4-6-2 locomotive moves across the Texas countryside toward Austin in 1949. (Courtesy of Museum of the American Railroad.)

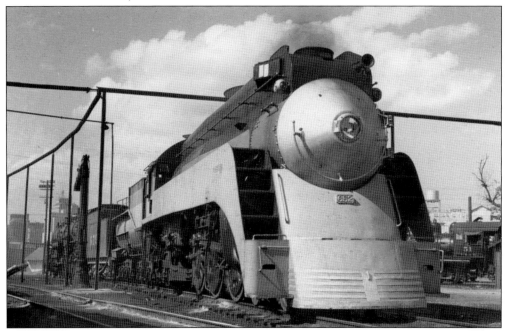

The Southern Pacific began making the transition from steam to diesel engines beginning around 1947. By this time, the Southern Pacific had 87 percent of the Cotton Belt Route. This image from 1949 shows a steam engine of the Southern Pacific railroad at the Cadiz Street Roundhouse in Dallas. (Courtesy of Museum of the American Railroad.)

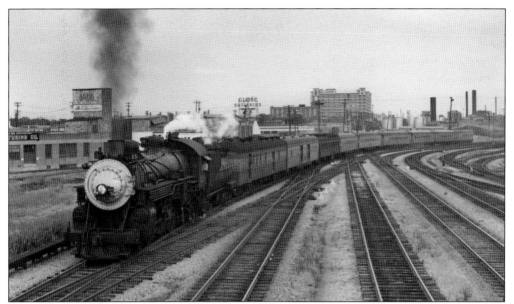

Railroads were in fierce competition with one another and raced to deliver passengers and freight to their destinations. This image shows the Southern Pacific P-6 class "protection" locomotive arriving in Dallas in 1949. The Southern Pacific at this time competed with the Fort Worth & Denver Railway over the Dallas-Houston route. Emergency engines were stationed along the route in Ennis and Hearne in the event that an engine failed so that the railroads still made it to their destinations with little delay. (Courtesy of Museum of the American Railroad.)

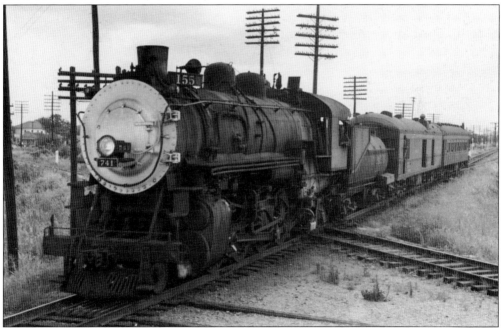

Railroads could combine passenger and freight services, as seen here in 1952. A Mikado-type 2-8-2 locomotive carries a mixed load of two cars with freight and passengers. The Southern Pacific Railroad operated this locomotive, seen traveling through Dallas. (Courtesy of Museum of the American Railroad.)

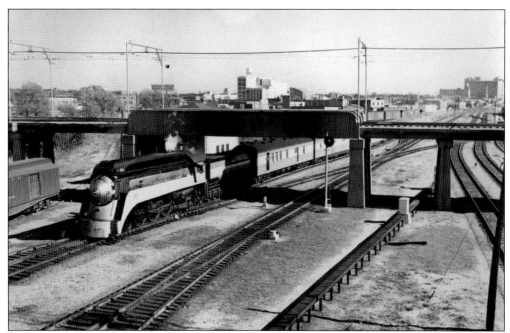

The Southern Pacific operated the *Hustler*, which was a slower counterpart for Houston-Dallas service to the *Sunbeam*. In this image, the 4-6-2 locomotive of the *Hustler* arrives at Union station in Dallas by passing under the old interurban railroad bridge that ran over the railroad tracks in Dallas. (Courtesy of Museum of the American Railroad.)

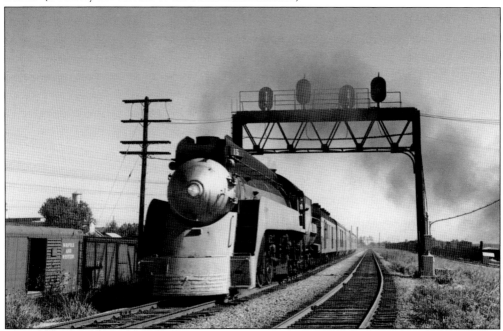

The Southern Pacific's *Sunbeam* made an afternoon run from Dallas to Houston while its sister service the *Hustler* came into Dallas from Houston in the morning. In this image, the *Sunbeam* is departing from Dallas in 1950 after picking up a parlor car. (Courtesy of Museum of the American Railroad.)

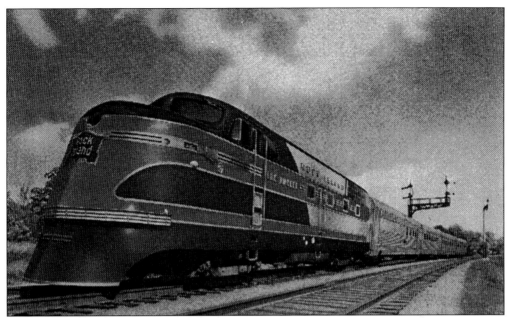

The Rock Island Railroad was a long-remembered railroad in Fort Worth history, having arrived in 1893. The railroad initiated the *Rocket* service in several strategic routes around the nation, its route in Texas being Fort Worth–Houston. In this image of the Peoria-Chicago *Rocket* service, the streamlined design of the locomotive is on full display. (Courtesy of University of Texas at Arlington Library.)

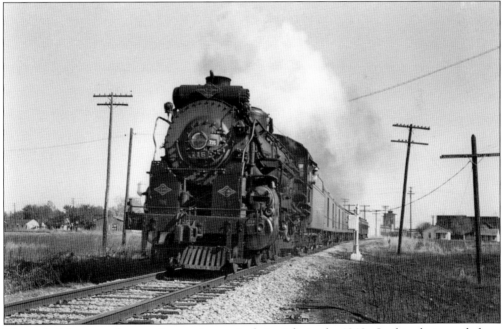

The end of the steam locomotive was increasingly in sight in the 1940s. In this photograph from 1949, a Texas & Pacific 4-6-2 locomotive enters Paris, Texas, traveling over the Transcontinental Division of the railroad's route between Texarkana to Fort Worth. (Courtesy of Museum of the American Railroad.)

Discover Thousands of Local History Books
Featuring Millions of Vintage Images

Arcadia Publishing, the leading local history publisher in the United States, is committed to making history accessible and meaningful through publishing books that celebrate and preserve the heritage of America's people and places.

Find more books like this at
www.arcadiapublishing.com

Search for your hometown history, your old stomping grounds, and even your favorite sports team.

Consistent with our mission to preserve history on a local level, this book was printed in South Carolina on American-made paper and manufactured entirely in the United States. Products carrying the accredited Forest Stewardship Council (FSC) label are printed on 100 percent FSC-certified paper.